INFRARED WEDDING PHOTOGRAPHY

Barbara Rice, Patrick Rice & Travis Hill

AMHERST MEDIA, INC. ■ BUFFALO, NY

Published by:
Amherst Media, Inc.
P.O. Box 586
Buffalo, N.Y. 14226
Fax: 716-874-4508
www.AmherstMediaInc.com

Publisher: Craig Alesse
Project Manager: Michelle Perkins
Senior Editor: Frances Hagen Dumenci
Assistant Editor: Matthew A. Kreib

ISBN: 1-58428-020-4
Library of Congress Card Catalog Number: 99-76585

Printed in the United States of America.
10 9 8 7 6 5 4 3 2 1

Notice of Disclaimer: The information contained in this book is based on the authors' experience and opinions. The authors and publisher will not be held liable for the use or misuse of the information in this book.

Table of Contents

The Authors

Patrick and Barbara Rice

Travis Hill

About the Authors

Barbara Rice

Cr. Photog., PFA, APM

Barbara Rice has had an extensive professional photography career that has allowed her to work at studios in four states over the past 20 years. Her formal photographic education is from the Rhode Island School of Photography and she has studied with many of the finest artists and photographers in the field. In addition, she has been trained in black & white and color printing, negative retouching, print enhancement and PhotoShop.

Her talent and creative style is well recognized. She was invited to photograph the wedding of President Bill Clinton's brother-in-law at the White House in Washington, D.C. She has been featured in several newspapers, appeared on television and her photographs have been displayed at the Kodak Gallery in New York.

Her portraits have won numerous awards in local, state, national and international competitions. She holds the Photographic Craftsman degree from the Professional Photographers of America (PPA) and the Accolade of Photographic Mastery degree from Wedding and Portrait Photographers International (WPPI). She is a popular lecturer and has presented programs to many photographic organizations on wedding photography, black & white hand coloring, print competition, infrared photography and Polaroid image transfers. She has lectured at the PPA's National Convention and at WPPI National Conventions.

Patrick Rice

PPA Certified, M.Photog.Cr. CPP, PFA, APM, AOPA, AEPA, AHPA

Patrick Rice has been a professional photographer for over 20 years. He holds a Bachelor of Science degree from Cleveland State University. He also holds the Master of Photography and Photographic Craftsman degrees from the PPA. He has been awarded the Accolade of Photographic Mastery, Accolade of Outstanding Photographic Achievement, Accolade of Exceptional Photographic Achievement, and is the only photographer ever to receive the Accolade of Highest Photographic Achievement from the WPPI. In 1997, he was named the WPPI Grand Award Winner in the Portrait category.

Patrick has had images and articles published in *Professional Photographer*, *Rangefinder*, *Wedding Photographer*, *Quarter Flash*, *In Focus*, and *Lens* magazines. His images have appeared in every issue of the WPPI coffee table books. He is the past editor of both the Society of National Ohio Professional Photographers (SONOPP) and the Akron Society of Professional Photographers (ASPP) newsletters.

He has also lectured and judged extensively all over the United States. At the Winona School of Professional Photography, he was a Super Monday instructor. He has served as an instructor at the Triangle Institute of Professional Photography in Pittsburgh as well as teaching college photography for three years.

Travis Hill

Travis Hill has been attending photography meetings and seminars for several years and assisting on wedding photography with his parents, Patrick & Barbara Rice for the past two years with incredible success. Although just a beginner, he has grasped both the concepts of photojournalistic and traditional wedding photography in both color and black & white. He is a member of SONOPP, ASPP, Triangle Photographers Association, the Professional Photographers of Ohio and the PPA.

He received three blue ribbons at the Triangle Photographers Association's 1999 Print Competition and is the youngest recipient ever to receive a Court of Honor Award in the Wedding Category at the MidEast States Regional Print Competition.

Interview with Patrick Rice

When did you start shooting weddings with infrared film?

Both Barbara and I have experimented with infrared photography on wedding coverages for many years, but it was just in the last few years that we found a processing lab that could give us 3½ x 5 proofs of our infrared images that really made this a viable form of photography.

Up until that point, we would receive contact sheets with uncorrected negative-size images on a single 8 x 10 piece of paper. It was impossible for our customers to make the best choices from such small and inferior reproductions. The ability to see a normal size proof allows our customers to enjoy the beauty of the infrared image as well as order images with confidence.

What interested you in this art form?

Barbara, Travis and myself have always been intrigued by the unpredictability of infrared film. Barbara's first Kodak image awards she received over 20 years ago were for images shot on Kodak infrared film.

The recording of a scene in a way that was not viewed by the human eye is part of the fascination. The images are bold, striking and dreamlike.

What are some of the most challenging aspects of infrared wedding photography?

Certainly the unpredictability of the film is a challenge. Our exposures are always bracketed to ensure that our clients receive usable images. Different materials reflect infrared light in different ways, and we have had to learn how to best utilize this to our advantage.

Subject placement in the scene is critical. You must make sure the subject does not blend in with the background.

What are some of the selling points of infrared wedding photography?

Many of our clients are looking for something different from the norm when it comes to their wedding images. This has led to the resurgence of black & white photography and wedding photojournalism. Black & white infrared photography is a bold step in a new direction for the industry.

We sell the clients on the idea of having infrared wedding images by showing them several sample prints from previous weddings that used this film. The images sell themselves with their beauty, mystery and uniqueness.

We have a handout advertising piece with three infrared images printed on it that we give to each prospective wedding client so they can take it home and show their friends and family what infrared wedding photography is all about.

What does infrared wedding photography offer that "regular" black & white and color cannot?

We have always been fascinated with the look you obtain from infrared film. Color film records a scene the way we see it. It is what it is. Black & white panchromatic films record the scene across a gray scale with lighter colors being rendered light gray and darker colors being rendered dark gray. These are certainly very pleasing, but infrared film is different.

Infrared radiation is recorded on the film in ways that are unexpected to the untrained eye. Grass and broad leaf trees glow and record nearly white — not dark gray or green like we would expect. Vivid blue skies are rendered nearly black with infrared film. Again, very different than what is expected.

It is these differences that make infrared photography so attractive to us and salable to our clients.

IMAGE I

Technical Specifications

This image was exposed on Kodak Infrared film. The camera, a Mamiya 645 Pro TL camera with a 35mm film back and a 55mm wide angle lens, was set at *f*11 at 1/125. A number 25 red filter was placed in front of the lens. It was a bright sunny day in the Fall and the couple was standing in the sun. The photo was taken around noon.

The Setting

In this photograph, Patrick was trying to record an intimate moment between the bride and groom. The pose was a natural embrace without either of them looking back toward the camera. Patrick simply asked the couple to hold each other close and just enjoy being in each other's arms.

The bushes behind them were starting to turn orange and amber with the seasons. The red filter helped to render these bushes lighter on the recorded image. Foliage is always a good background choice when using infrared film because it is very sensitive to infrared radiation and renders a striking effect on the film. The range of light and shadow on the bushes and trees covers almost the entire gray scale of the film and paper – it comes alive with the infrared film.

Infrared Differences

All infrared photos differ from regular black & white photos in the way they render a scene. In this case, the orange and red leaves on the bushes and trees would all record as dark grays on regular black & white film, whereas with the infrared, they record far lighter in color and almost white in places.

The same is true for the grass the couple is standing on. Regular black & white film records grass as a darker gray tone, but in infrared it is very light and almost white. In addition, the satin lapel on the Groom's jacket as well as the satin stripe on his trousers reflect infrared light differently than the rest of the material and record as nearly white with the infrared film. With regular black & white film, the tuxedo remains completely black.

Film Choices

There are two "true" black & white infrared films — Kodak High Speed Infrared and Konica 750nm Infrared. The Kodak High Speed Infrared film is only loaded in 35mm and sheet film. We only use the 35mm variety. The Konica 750nm Infrared film is available in both 35mm and 120 formats.

We prefer to use the Kodak High Speed Infrared film for a number of reasons. First, it is the most infrared sensitive film available for photography. Visible light is measured between 400nm to 700nm. The Kodak emulsion will record down to nearly 1300nm (nanometers). The Konica film has peak sensitivity at 750nm and extends just beyond that point. Thus, the Kodak film records more of the infrared radiation falling on a scene than the Konica film can.

Second, the Kodak film is a "faster" film than the Konica film. All things being equal in a scene, the starting point for exposure is two stops faster (more light sensitive) for the Kodak film than for the Konica film.

Third, the Konica film has an anti-halation layer built into the film that prevents the images from having that "glowing" aspect that you see with the Kodak film. We really like that halation and feel it adds to the dreamlike quality of our images. Both Ilford and Agfa make a "pseudo" Infrared film. Neither is an infrared film — they are both panchromatic films with extra sensitivity in the red range.

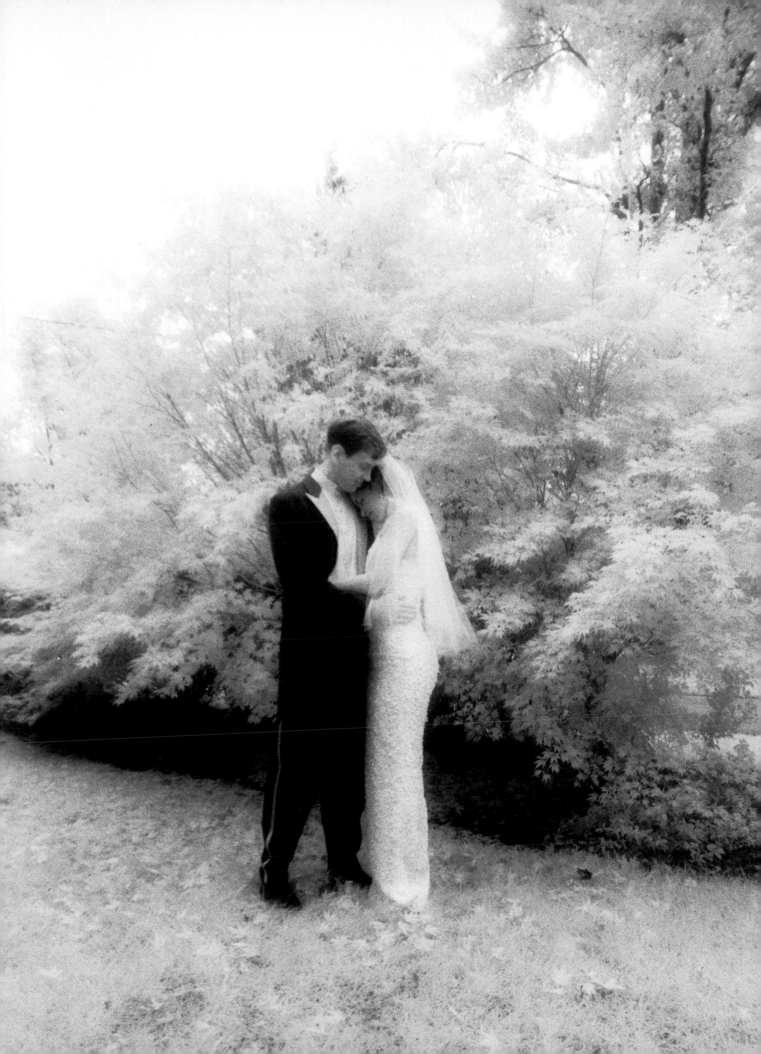

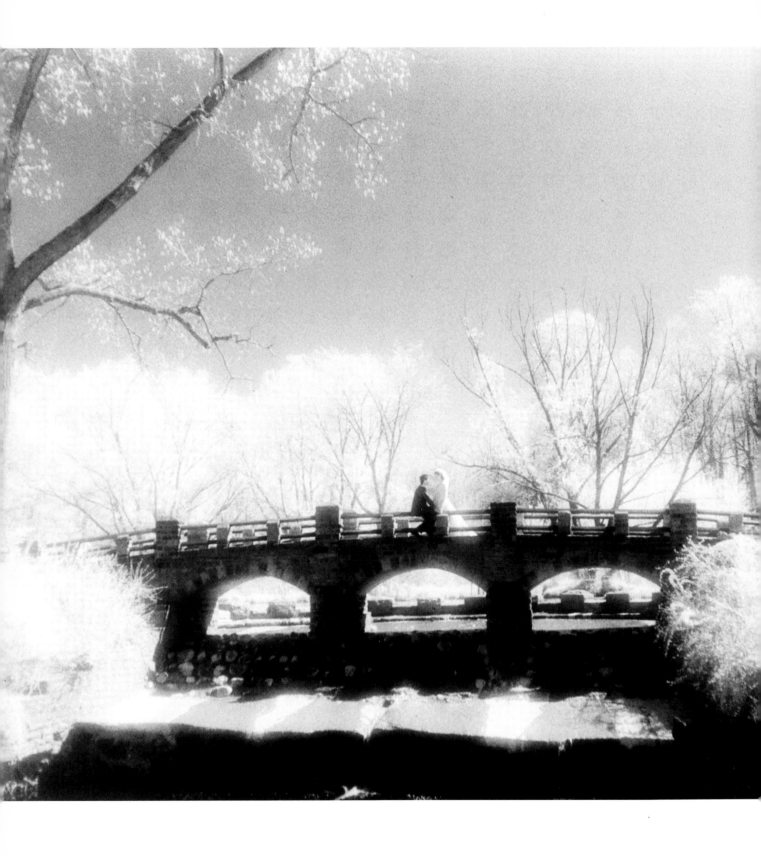

Technical Specifications

A Minolta XD 5 35mm camera with a 28mm wide angle lens was used. A number 25 red filter was placed in front of the lens. The film was exposed at ƒ11 at 1/250 on a bright sunny day at mid-afternoon.

The Setting

All of our photographs are meant to express the love between the bride and groom on their wedding day. We choose the poses that best express those feelings. In this image, Patrick chose this beautiful old bridge as the focal point of the image. The bride and groom are looking at each other and the photo has a candid appearance to it. The trees were used to frame the photograph. The contrast between the bridge (which doesn't reflect much infrared radiation) and the foliage is quite striking.

Infrared Differences

As in most infrared photographs, the foliage really makes this image different than regular black & white work. The contrast is also more distinctive because of the lack of infrared radiation on the bridge compared to that of the trees and bushes.

Handling Film

Kodak High Speed Infrared film must be loaded and unloaded in absolute darkness. The film comes in a light-tight, black plastic film container which it must be returned to after the film has been exposed and removed from the camera. (Konica Infrared film can be loaded and unloaded in subdued light.)

No darkroom safelights can be on when handling Kodak Infrared film and if a commercial lab processes your film, the lab must turn off any infrared lights they may use during normal processing operations. If a darkroom is unavailable to you, a film changing bag can be used for the loading and unloading of your film. We highly recommend that every wedding photographer carries a changing bag with them on all jobs just in case they need to open any camera and any film during the wedding day.

The Kodak film should be kept in the refrigerator or freezer prior to use. Allow film to slowly warm to room temperature (about two hours) when taking it out of the refrigerator to prevent condensation.

If it is hot outside, keep your camera loaded with infrared film in a cooler or cooler bag to keep it from getting too warm. Never leave a camera with infrared film in a hot car. Always bring the camera with you into the church and reception site — even if you are not using the camera and film in those locations. Infrared film should be processed as soon as possible after exposure.

INFRARED FILM

**OPEN IN
COMPLETE DARKNESS**

Left: We use a red infrared sticker like this one to place on film canisters and lab processing bags. This sticker alerts whoever handles the film that it is infrared and must be opened in complete darkness.
Right: A Kodak infrared film box with the warning about loading and un-loading the camera in complete darkness.

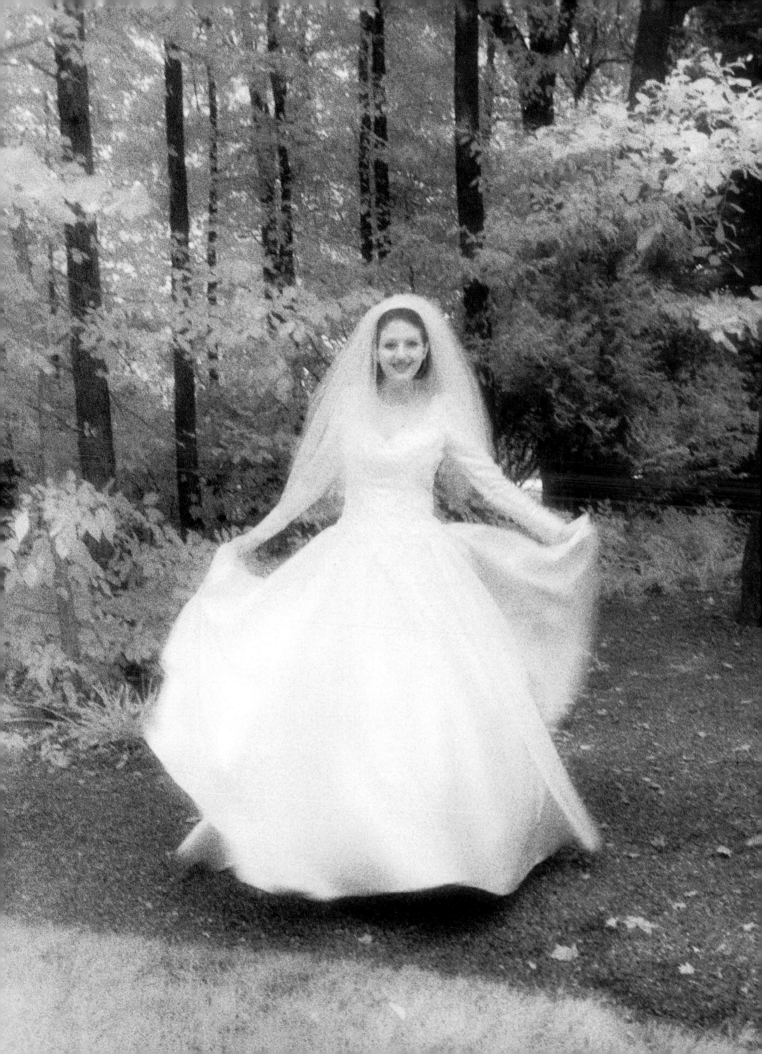

Technical Specifications

The camera used was a Pentex ME 35mm with a 28mm wide angle lens. The lens had a number 25 red filter in front of it. The exposure was $f11$ at 1/30 of a second, using Kodak infrared film.

The Setting

This was a playful image that Barb created of the bride on her wedding day. The idea was to create a "fun" picture to show the joy of the wedding. Barb had the bride spin her dress so that there would be some motion in the image. Barb helped enhance the feeling of movement by slowing down the camera shutter speed to 1/30 of a second. The image was taken in a clearing in a park close to the church where the bride got married. The photo was taken on the wedding day.

Film and Grain

All high speed films are more grainy than slower films. It doesn't matter if the film is infrared, panchromatic black & white or color.

Black & white infrared film will look more or less grainy depending on how you photograph the subject. If it is a bright sunny day and the subject is in the sun, the subjects will be less grainy than if they are positioned in the shade. When the overall lighting is more overcast, the infrared images are also more grainy. Grain adds a characteristic softness to an image which enhances the quality of these soft, dreamy photographs.

Camera Selection

We are using both medium format cameras and 35mm cameras to shoot Kodak 35mm Infrared film. With our Mamiya 645 Pro TL cameras, we use the optional 35mm film back and load/unload the infrared film in absolute darkness.

In addition, we use both older and newer 35mm camera bodies to shoot Kodak infrared film. With older 35mm cameras, it is important to have the film back light seals checked before shooting any film. Dried out light seals can allow some light to pass through the back and create some fogging of the Kodak 35mm infrared film. Some of the newer autofocus 35mm cameras have a built in infrared LED to count the films sprocket holes for film transport purposes. This is especially true with many of the Canon EOS cameras (see below). If you use infrared film in these bodies, you will experience some film fogging on the bottom of the frame.

Canon EOS Bodies & Infrared Film

Some EOS bodies use an Infrared LED to count sprocket holes for film transport purposes. Since the LED operates in the infrared spectrum, the combination of infrared film and EOS body can cause fogging on the film. However, there are three factors to keep in mind. First, not all infrared films are equally sensitive to infrared light. Only the Kodak HIE High speed infrared and the Ektachrome (color) infrared are sensitive enough to be affected by this fogging. Konica 750 IR can be used without any problems; the new Ilford EXR-200 is claimed to have the same sensitivity at the Konica, and should therefore work fine. Second, even with both Kodak films, you won't fog the entire film — only 4mm on the bottom of the frame (the LED counter is on the top right inside the camera, the image is taken upside-down). Third, not all EOS cameras use the LED counter. Here is a list of all cameras that have the LED and the ones that have a mechanical sprocket. This list is in chronological order (• = LED; x = Sprocket):

650	x	RT	x	1000 N/Rebel II	•	KISS (500, Japan only)	•
620	x	10	x	1000 FN/Rebel IIS	•	In	x
750	x	700	x	1000 S (FN, Japan only)	•	In RS	x
850	x	1000/Rebel	x	5/A2E	•	50 E/Elan II	•
600/630	x	1000 F/Rebel S	x	500/Rebel XS	•	50 E/Elan II E	•
1	x	100/Elan	•	Rebel X	•	55 E (Japan only)	•

IMAGE 4

Technical Specifications

Patrick used a Mamiya 645 Pro TI with the 35mm film back and a 55mm wide angle lens to take this photo. A number 25 red filter was used in front of the lens. The exposure was $f11$ at 1/250 on a bright sunny day.

The Setting

This image was taken on the wedding day after the ceremony and before the reception on the grounds of the Cleveland Museum of Art. It was a beautiful sunny afternoon (about 3:00pm) and the goal was to incorporate the exquisite surroundings of the Art Museum with the bride and groom. Patrick wanted the couple focused not on him, but rather just looking off and thinking about the start of their new lives together. One of the interesting aspects of this image was that the groom had a white tuxedo with a black satin lapel. With the Kodak infrared film, the black satin lapel reflected all of the infrared radiation and rendered white on film!

Using Other Types of Film

In many cases, we will photograph the same pose in both color and infrared, or regular black & white and infrared, or even all three. This is effective because it really shows the subtle differences between "normal" films and the mysterious infrared film. On some weddings, a certain amount of time is set aside for infrared photographs, although at least a few regular images are usually shot as well from the sequence.

Filters

In order to block the visible light from recording onto the infrared film and overwhelming the infrared rendering of a scene, it is necessary to use filters to block most of the visible light. A number 25 (red) filter will block most all of the visible light and give you a very pleasing infrared image. The red filter has a 2½ stop filter factor, so the exposure must be adjusted accordingly.

You can also use a number 87 (infrared) filter and block all visible light. This filter is opaque and you must focus and compose your image before placing the filter in front of your camera lens. It has about a 5 stop filter factor.

The number 25 red filter is our filter of choice for infrared because it blocks nearly all of the visible light, and you can still see through it for focusing and composing the image.

When using our fisheye lenses, we use the number 16 orange filters. With the Mamiya 24mm fisheye lens and the Minolta 16mm fisheye lens, it is very difficult to place a filter in front of the convex front element of the lenses. These lenses do, however, have built-in filters that you can "dial up" to use for your photographs. Neither of these lenses have a built-in red filter, but they both have built-in orange filters. The infrared effect is slightly less than with a red filter, but still very effective. The filter factor is 1½ -2 stops with the number 16 orange filter.

Here is the entire line of Tiffen professional filters. When using infrared film, the following filters are recommended: red #25, # 87, #87C, #89B, #113, and orange #16. Photo courtesy of Tiffen.

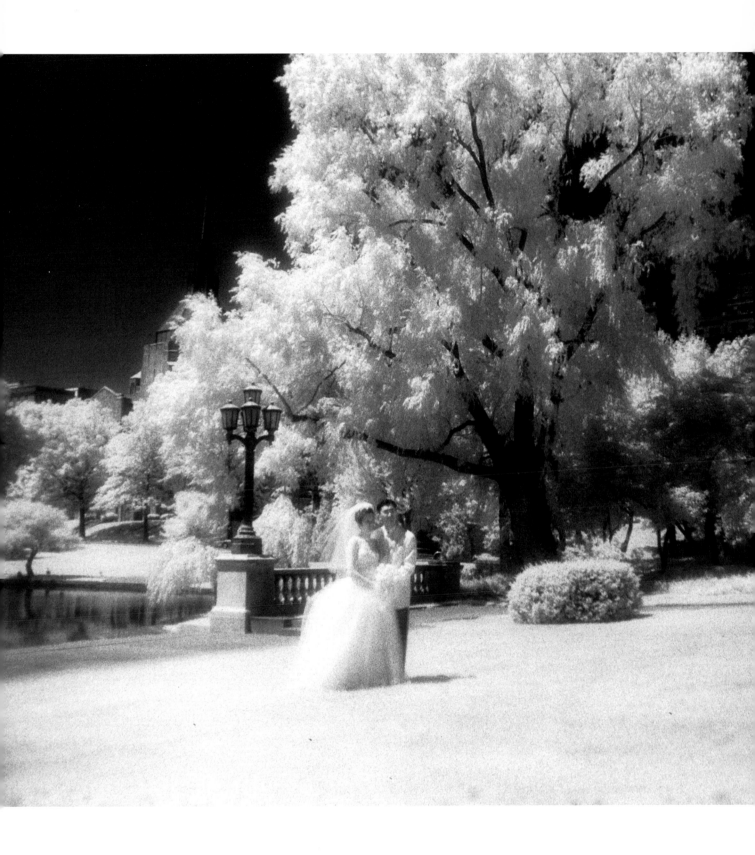

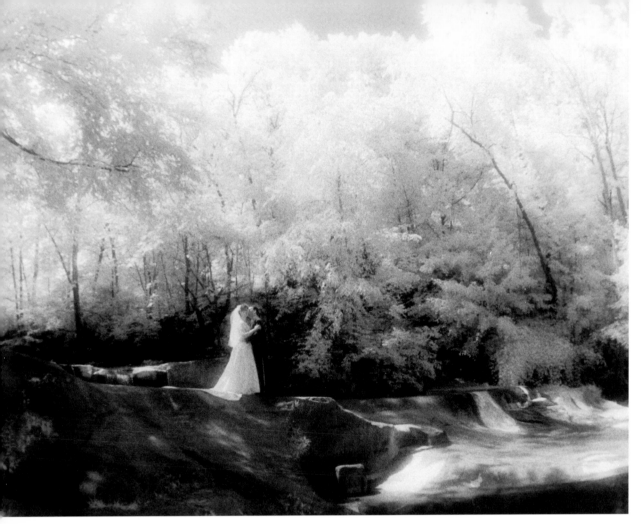

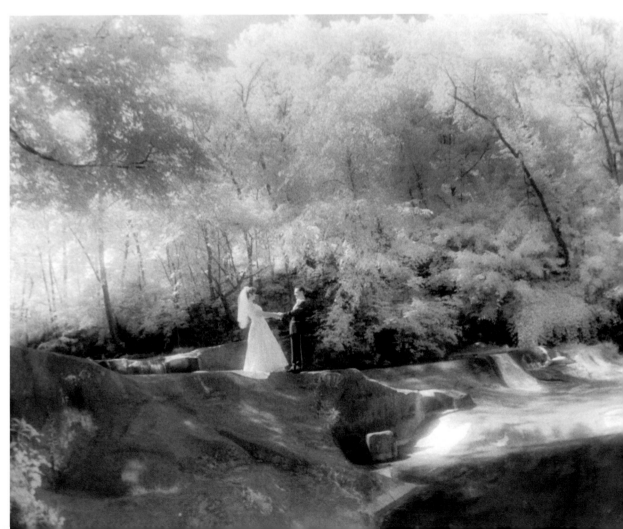

Technical Specifications

Both of these images were photographed by Barbara on the couple's wedding day. She used a Canon 35mm camera with a 28mm wide angle lens for both. A number 25 red filter was placed in front of the lens. The images were taken within a couple of minutes of each other as part of a sequence in the mid afternoon. The exposure was f8 at 1/60 of a second.

The Setting

Barbara was trying to convey the fun and playfulness between the bride and groom in these images. From the little kiss on the side of the cheek in one image to the holding hands and leaning away in the other, you see nontraditional wedding portraits.

The couple was looking for some "less traditional" imaging on their wedding day and Barb achieved this nicely with the posing and the film choice. The photographs were taken in Olmsted Falls Community Park. This setting is down a hill and very secluded with a small stream that leads to the waterfall. It is a very popular location for our couples to have their environmental portraits taken.

Differences between the Images

The differences between these two images was due to the changing light conditions on the day when they were photographed. As the sun pops in and out from behind the clouds, the amount of infrared radiation being recorded on the film changes. This subtle change in lighting has a dramatic change in the resulting infrared image.

Posing

Much of the posing of couples on their wedding day is very stiff and boring. The couple is usually standing with one arm around each other staring back at the camera. While this pose is fine for some images on the wedding day, the photographer must go beyond this pose and record images that show the love, emotion, fun and playfulness of the couple they are photographing.

These images are a great example of two creative photos that can be taken in sequence without taking a lot of time to repose. These poses flow from one pose to the other, making it a smooth and quick transition.

With infrared film, it is usually best to take the photographs from 25+ feet away from the subject to pick up more of the infrared radiation in the scene.

In addition, it is recommended to not have the subjects looking back into the camera lens because blue eyes will change to black much like blue skies do. The black eyes are not very flattering in a wedding image.

IMAGE 7

Technical Specifications

Travis took this infrared photograph on the couple's wedding day. He used a Minolta 35mm camera with a 28mm wide angle lens. A number 25 red filter was used in front of the camera lens. The exposure was ƒ11 at 1/250 on a bright sunny day.

The Setting

Travis was trying to convey an image where the groom was in a more gallant or noble pose in the way he was addressing the bride. He was able to get the couple to pose in this manner by using an image he preselected from a bridal magazine dress advertisement. He chose a low camera angle to shoot up towards the couple and the sky. He was about 15 feet away from the couple when he shot the image. The setting was just outside of the church in the courtyard area on the church grounds. The couple liked the flowers and landscaping — many images were taken in this spot — in color, regular black & white and infrared.

Scouting Locations

We typically do not scout out locations prior to the wedding day, although we have done so on occasion. Over the last 21 years of photographing weddings in the Cleveland area, we are very familiar with the parks and most of the church and reception sites.

Shooting On Location

Once we arrive at a site, we quickly set up the equipment and make sure all of the cameras and film backs are loaded and ready to go. Once we begin photographing, we want to spend as little time as possible changing film.

Our infrared film is always in a separate camera or camera back. The same is true for our regular black & white films. In this way, we can switch from color to regular black & white to infrared without wasting any time. If possible, we like to give the couple the same poses in two or three different film types so they have a greater variety than they would receive from other studios.

We typically have two photographers on wedding events, although Barbara and Patrick do shoot alone on some weddings. Travis assists as the second photographer only at this point and is not the primary photographer on the wedding. On weddings with Patrick, Travis will usually shoot the regular black & white and also the infrared while Patrick concentrates on the color images.

On some very large wedding events, all three of us will shoot photographs, We each have our specific goals for the wedding and we each shoot using different cameras and films.

IMAGE 8

Technical Specifications

Travis took this photograph inside the church while the wedding ceremony was taking place. He was using a Minolta 35mm camera with a 28mm wide angle lens. A number 25 red filter was used in front of the lens. The exposure was $f4$ at 1/4 second on a tripod from the back of the church.

The Ceremony

Various churches and temples have very different rules about photography even among the same denomination. It is always best to check with the Priest, Minister, Rabbi, etc. about their specific regulations for the wedding photographs. We would never break a church rule when it comes to photography. Too many photographers have been banned from churches and temples for taking liberties during the ceremony that were forbidden by the officiant.

The most common restriction during a wedding is to not allow the use of flash photography after the bride has reached the front of the church. In these cases, we use very fast films (Kodak, Fuji and Konica 800-3200 speed films) and we take photographs from the back of the church and the balcony with the camera on a tripod. We will go back into the church and recreate some images if we were not able to get a quality photograph during the actual ceremony. The most common recreated photographs are the ring exchange and the lighting of the unity candle.

Shooting Indoors

Because of the way the lights and outside windows will glow when using infrared film indoors, the photographer must be sure to not let this "glow" overwhelm the image. The film is still exposed with a red filter in front of the lens and the starting ISO/ASA is about 100 with no flash illumination.

A tripod is necessary to freeze the image and prevent camera movement on longer exposures such as this one. Another consideration is to remember that anything red in color will record nearly white with the infrared film and the red filter over the lens.

Using Filters & Flash Indoors

We still use the number 25 red filter in front of the camera lens with our indoor infrared images. We generally do not use flash during the wedding in the church or temple and just use a tripod with a longer exposure. We will, however, use flash with the infrared film at the wedding reception. The resulting images are very striking. The satin on the tuxedos still records very light (nearly white) when a flash is used. The film is rated at about 50 ISO/ASA with flash. The flash falls off very quickly in the resulting image which creates incredible contrast between foreground and background. The backgrounds are nearly black even though the subject in the foreground is well illuminated. If the subject is wearing white or a very light color, they will "glow" when an infrared image with flash is shot.

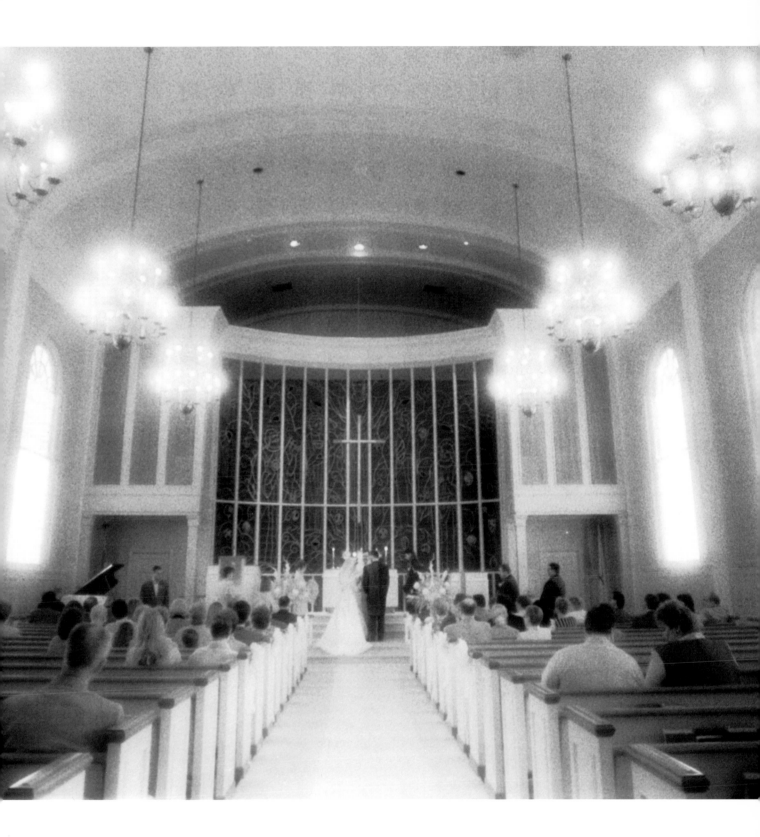

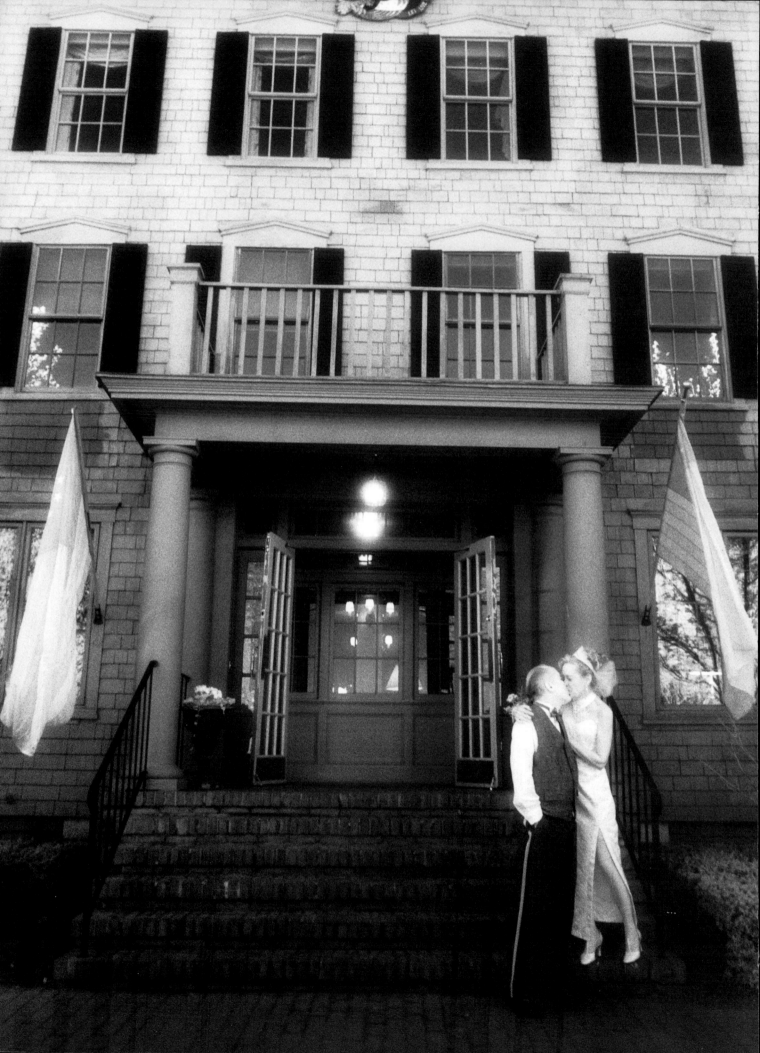

Technical Specifications

Barbara created this photograph with her Pentex 35mm camera and a 28mm wide angle lens. A number 25 red filter was used in front of the lens. The exposure was $f5.6$ at 1/60. She used a low camera angle to shoot up at the couple and the outside of their reception hall.

The Setting

Barbara was trying to capture a natural moment on the couple's wedding day. The purpose was to create an intimate image of the couple kissing. It is a bit more whimsical because the bride stood on top of the step to get taller when she was kissing the groom. The setting for the photograph was just outside of the reception hall before the bride and groom were going to begin their dinner. The sun was setting behind the building and the couple was in the shade on the front steps.

Lighting

This photograph was taken at 7:00 in the evening just before the reception dinner was to take place. The sun was setting behind the building and the couple was in the shade.

There is no "better" or "worse" time of day for shooting infrared film — the results are simply different based on the natural light. As the sun sets at dusk, there is more infrared radiation because the color temperature of the visible light drops from over 5000 Kelvin to around 3000 Kelvin. In other words, the light at dusk is more red in appearance. Images certainly are rendered differently based on the time of day and intensity of the sunlight. Backlighting can produce very dramatic "glowing" appearances in the photographs. It all depends on the photographer's personal objective for the image. As the sun sets, the photographer will need to open up the lens one or two stops to ensure a proper exposure.

Focus Considerations

Because infrared radiation focuses at a different point than visible light, it is necessary to readjust the lens focus on your camera. Many lenses are marked with a small red line or "R" to show you the infrared re-adjust mark. Simply put, after you focus the lens on your subject, you must move that focus point back to the infrared mark to have the infrared image properly focused on the film.

By using smaller lens openings ($f8$, $f11$, $f16$) you will not have to worry as much about refocusing for infrared because of the increased depth of field or area of acceptable focus when using these small lens openings. We generally set the lens at $f11$ on a sunny day and adjust the shutter speed when we bracket the exposures.

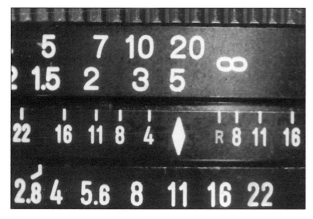

The lens is focused at 20 feet.

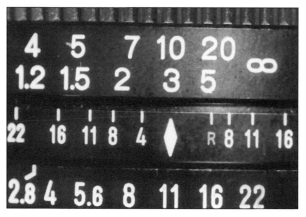

The lens is refocused to the infrared "R" mark.

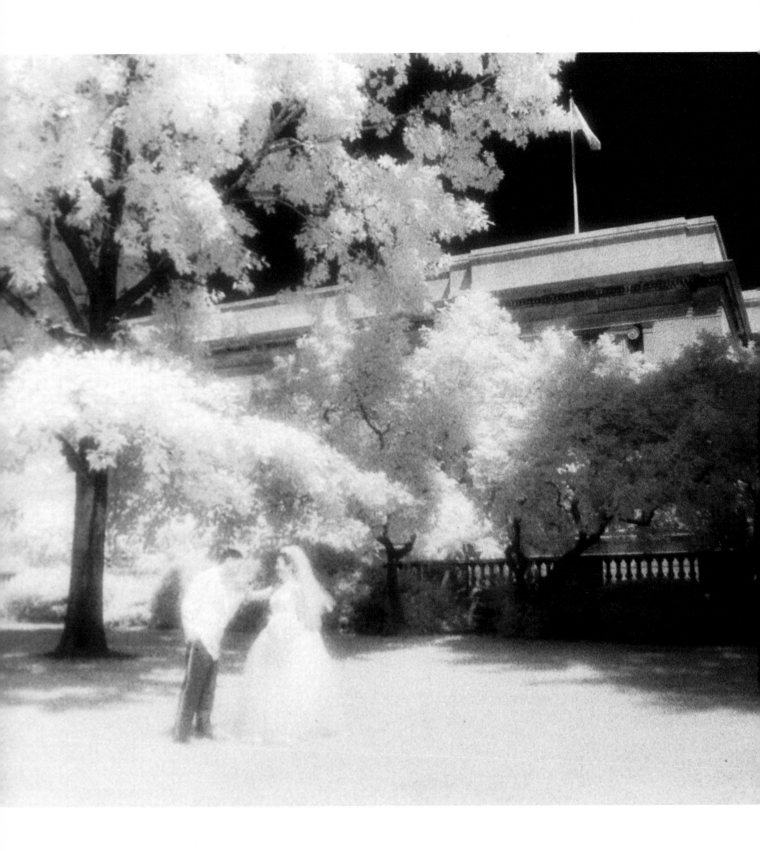

Technical Specifications

Patrick took this photograph of the bride and groom on the grounds of the Cleveland Institute of Art. It was a bright, sunny day. The photo was taken at approximately 4:00 in the afternoon. He used the Mamiya 645 Pro TL camera with a 36mm back and Kodak infrared film. He had a 55mm wide angle lens with a number 25 red filter on it. The exposure was $f11$ at 1/250.

The Setting

In this photograph, Patrick was trying to create a very classical romantic image of the bride and groom. The groom about to kiss his bride's hand is a symbolic wedding image.

The groom having his hand in his pocket adds to the casualness of the pose and the bride and groom are clearly relating to each other and not posing for the camera.

The photograph was taken in the bright sun on the grounds of the Cleveland Museum of Art in front of several trees with the main building filling out the background.

Composition

For this photo, Patrick placed the couple in the lower left corner of the photograph to balance the darker area in the right side of the photograph. He used a low camera angle and shot up towards the couple to record both them and the beautiful surroundings. In this shot, Patrick likes the differences in the illumination of the foliage and how it recorded on infrared film.

The image location has a secluded look because the couple is surrounded by beautiful trees and the classic building completes the background. The Groom's white tuxedo jacket with the black satin lapel is certainly appealing because the black satin is rendered near white with the infrared film.

Lighting & Shadows

With infrared film, there is more contrast in the overall image when it is bright and sunny than a regular black & white image. When it is overcast, the image has less range and is flatter in appearance — similar to a regular medium contrast film. The shadow areas with infrared film are generally darker and have less detail than most medium contrast black & white films.

The Mamiya 645 Pro TL.

IMAGES 11 AND 12

Technical Specifications

Patrick used a Minolta 35mm camera for both photographs. In the top image, he used the Minolta 16mm fisheye lens; on the bottom image, he used a Minolta 20mm lens. With the fisheye lens, a built-in orange filter was used. With the 20mm lens, he used a number 25 red filter. Both exposures were on Kodak infrared film at $f11$ at 1/250. The couple was placed in the direct sunlight for both images. Kodak black & white infrared film was used for both.

The Setting

Patrick took both of these photographs at about 10:00 in the morning on a scheduled reshoot with the bride and groom. They were not able to go to this particular location (Squires Castle) on their wedding day and wanted dramatic images in front of this historic castle on Cleveland's East Side. He was looking to create a very dramatic image for the bride and groom and wanted it to have a "fairy tale" quality.

To create the image, Patrick was assisted by fellow photographers David and Karen Neldon. The long veil was 108" wide tooling from a fabric store. We attached 30 feet of tooling behind the bride's real veil and hoisted the veil up over the top of the castle with two sets of ten foot electrical conduit pipe. We then had the bride move far enough away from the castle to create a sweep in the veil and give the "fairy tale" appearance to the image.

Squires Castle is a small historic castle on Cleveland"s East Side. It is now part of the Cleveland Metroparks and is a popular gathering spot for the public. We chose to go early on a Sunday morning to have less interference by the public.

Differences Between the Images

The differences in the sky exist because the sun was popping in and out between the clouds. The infrared radiation that is recorded on the film will change depending on the intensity of the light. The other difference is that the fisheye lens gives the appearance of being much further away from the subject — thus the film is recording much more of the infrared in the scene — thus the darker blue sky. The image with the 20mm lens also has some lens flare in it which lessens the overall crispness of the image.

Composition

The poses of both of these photographs flowed from one to another and are very similar. The different lenses gave differing looks to the images. In the image on the bottom, the bride and groom are in the lower center of the image. The low camera angle allowed the recording of all of the castle as well as the sky above it. In the top image, the couple was intentionally distorted by having them in the lower right side of the image and bending with the slope of the horizon line.

When you use a low angle with a fisheye lens and tip the camera up, the horizon line raises in the corner — or, as we like to tell our clients, the world smiles at them. The fisheye lens records much more of the scene that the ultra-wide 20mm lens because the fisheye lens records nearly 180 degrees of the scene.

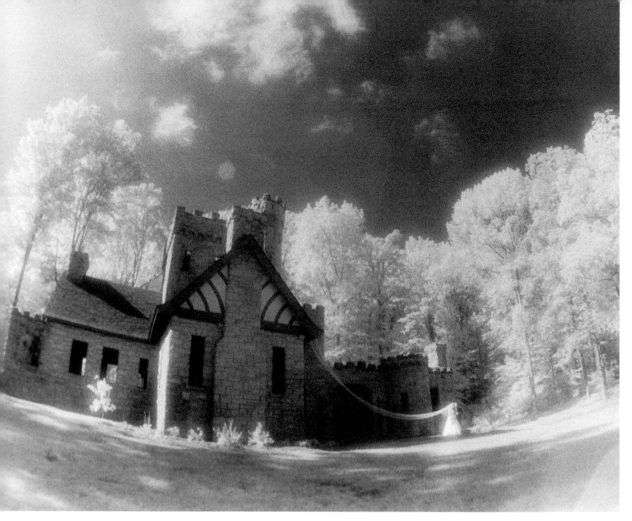

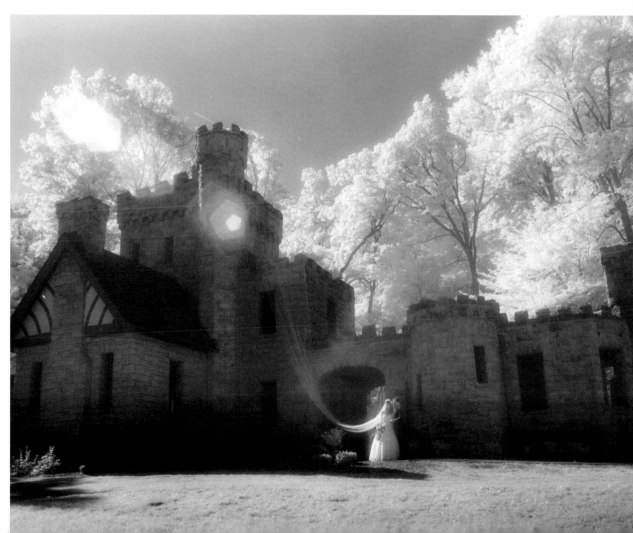

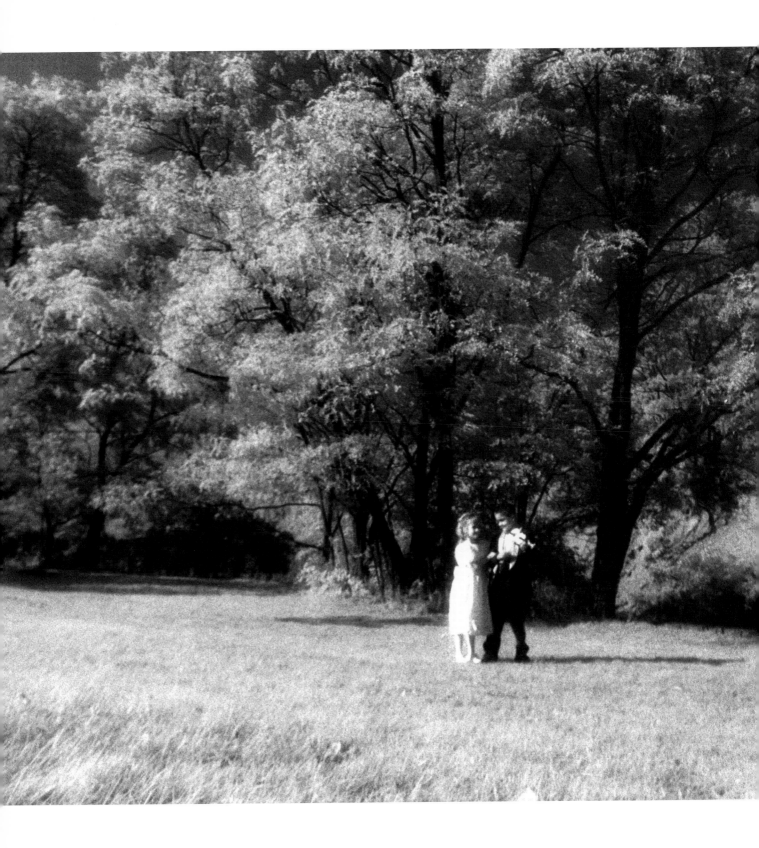

Technical Specifications

Travis created this photograph of the flower girl and ring bearer on the bride and groom's wedding day. He was using a Canon 36mm camera with a 28mm wide angle lens. He used a number 25 red filter in front of the lens. The photograph was taken at about 5:30 in the afternoon on a bright sunny day. He exposed the photograph on Kodak infrared film at $f11$ at 1/250.

The Setting

We utilize props in many of our wedding images such as musical instruments. In this photograph, Travis decided to have the ring bearer and flower girl act as miniature bride and groom and had them create a romantic image instead of the using the couple. We sell a great deal of images of the children in wedding parties to the bride and groom, their friends and families.

We feel many photographers overlook these little "scene stealers" and the profit potential they can generate. Travis gave the little boy a very small red imitation violin to use as a prop for this photograph. We found the violin as a Christmas decoration and the size is similar to a reduced scale child's violin. The red color of the violin is especially attractive because it records nearly white in the image and stands out against his black tuxedo. The image was created in a very narrow park area on the way to the reception hall.

Photographing Children

The key to photographing children on weddings is to work quickly and be completely ready to take the photograph before you pose them. We will always work with the bride and groom by themselves before we start trying to get the children in the photographs.

The children are easily bored, so you must work fast and not try to keep their attention for a long period of time. In most cases, we would take a photograph with the entire bridal party (including the children) and then give them a little time before we ask them to be in more photographs. To children, standing still for five minutes seems like an eternity and they begin fighting and not paying attention. By being ready to shoot once they are posed and breaking up their portion of the photo session, we are able to capture wonderful images of very small children on the wedding day.

Composition

Travis used a very low camera angle (he was laying on the ground) and placed the children in the right side of the image. The low angle allowed Travis to record the very tall trees in this park area and give the children a bit more presence in the image. The trees in this photograph are darker than they would normally be on infrared film because of the time of day and direction of the light.

The photograph was taken at about 5:30 in the afternoon and the light was very directional, giving a long shadow to the ring bearer. The reason the trees are darker in this image than in most images is because the sun is not falling directly on the trees — they are sidelit like the children — thus reducing the amount of reflected infrared radiation being recorded on the film.

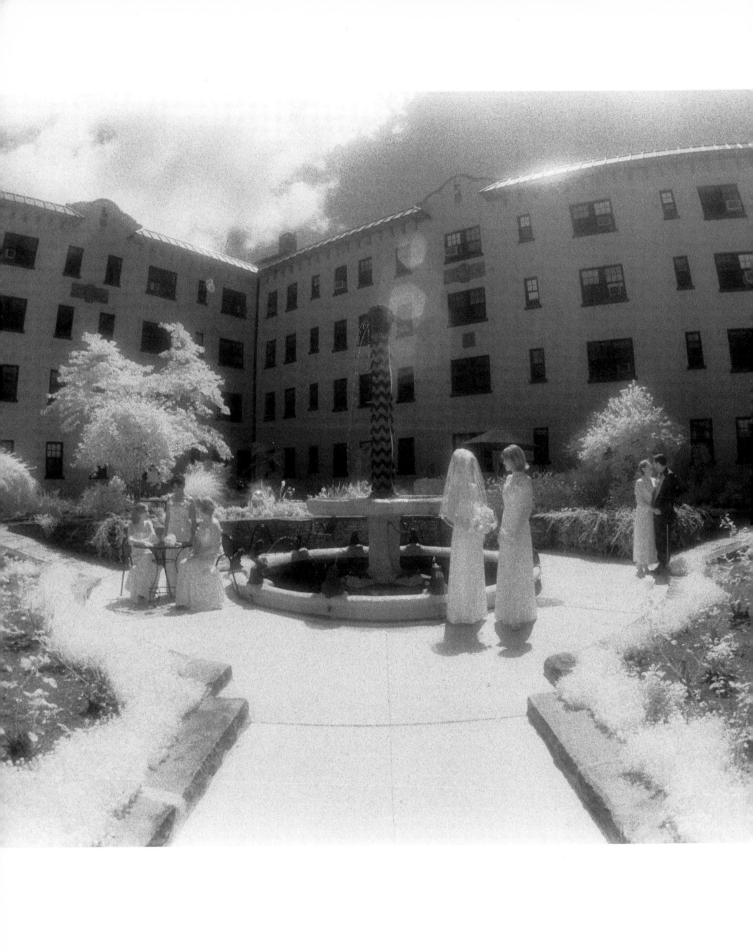

Technical Specifications

Barbara created this photograph of the bride, her bridesmaids and the bride's parents before the ceremony at the hotel where the bride got dressed. She used Kodak infrared film exposed at $f11$ at 1/250 with her Canon 35mm camera and a Sigma 16mm fisheye lens. The Sigma lens had a rear element red filter attached to it. The photograph was taken at about 1:00 in the afternoon in the hotel's courtyard.

The Setting

Barbara wanted a story-telling image of the bride's wedding day. She used a fisheye lens and a high camera angle to give the viewer the feeling of peeking in on a candid moment on the wedding day. The beauty of this hotel courtyard lent itself nicely to the dream-like quality of the Kodak infrared film. The subjects were placed in small groups relating to each other — not posing for the camera. There is a sense of realism in this image that is lacking in many wedding photographs. Even allowing the sun to flare in the image adds to the feel of the photograph and the glow of the bride in her gown.

Composition

Barbara composed this photograph by separating the bride and maid of honor, the rest of her bridesmaids and her parents into three separate groups that are relating to each other. Together they tell the story of relationships of the people involved in the wedding day in a manner that is believable and pleasing to the viewer. The bride and maid of honor were placed in the foreground of the photograph to signify their importance to the event while the other groups are positioned to the sides to be visible but not overpowering.

Posing

The trend in wedding photography in the 90's was a significant movement to wedding photojournalism. Industry leaders like Denis Reggie, Clay Blackmore, Bambi Cantrel, Andy Marcus and others showed wedding photographers that wedding images could be more than just posed photographs. All a photographer has to do is study the advertisements in leading bridal magazines and they will see new ideas and ways to pose the bride and groom in images on their wedding day. We have utilized these magazine advertisements to help us to communicate what we want our couples to do in front of our lenses. We have achieved a more natural look to our photographs that is both interesting and profitable.

Wedding Albums

Our couples always create albums that have a combination of all of the different films that we use. The infrared images, as well as the regular black & white, are mixed with the color images to tell a unique story of their wedding day. We use the Renaissance line of wedding albums and folios for our wedding photography. The all black pages and the black pages with silver trim look especially good with infrared photographs. Photographers can purchase the Renaissance line nationally from Albums Inc. at 1-800-662-1000.

The Renaissance line of albums offers black pages and silver trim options, which look good with infrared photos.

IMAGE 15

Technical Specifications

Travis took this photograph with a Minolta 35mm camera and a 20mm lens on Kodak infrared film. The lens had a number 25 red filter in front of it. The photograph was taken in the park after the wedding ceremony — about 4:30 in the afternoon. The exposure was *f*11 at 1/125.

The Setting

The setting was an open area in a park near to the church. The sun was beginning to drop behind the trees — thus giving the long shadows. The idea behind this photograph was to recreate the moment when the groom proposed to the bride many months before.

Through our consultations with the couple prior to the wedding, we learned that the groom proposed on one knee to the bride one afternoon in the park. The couple was very excited to have us create a visual reminder of that special moment in their lives.

Patrick took a color image of this pose from the ground, while Travis climbed up on a picnic table and shot the infrared. He decided to use a high camera angle so the viewer would be looking down on the couple in much the same way that the bride was looking down toward the groom. The picnic table happened to be there at the park — Travis made sure that the couple was posed in such a way that he could take advantage of the placement of the table (the table was bolted down and couldn't be moved). He had the couple turned and posed in such a way that he was able to get clean profiles of both the bride and groom.

The very directional lighting with the late afternoon sun is always appealing with the infrared film. With the bride's dress to the sun, she literally glows and radiates off the page. The pose was very romantic and had special meaning to the bride and groom. Images like this are a sure sell to the couple, thus they are highly profitable.

Exposure

Infrared film does not have a true ASA or ISO setting. Light meters are of little use because they are made to measure visible light, not infrared (invisible) light. With all infrared film, the exposure outdoors will depend on the natural lighting conditions present. On a bright, sunny day, with the couple standing in the sun, a starting point for exposing your Kodak infrared film would be *f*11 at 1/125 with the number 25 red filter in front of the lens. It is important to bracket your exposure — typically down one stop and up one and two stops — to ensure a perfect negative for printing.

In wedding photography, it is far less costly to take a couple extra exposures than it is to ask the bride and groom to go back and try to recreate an image because the exposure wasn't acceptable. With the Konica infrared film, the starting point is *f*5.6 at 1/125 — two full stops slower than the Kodak film. If it is cloudy, you would open up the lens two stops and bracket in the same manner. Exposure will change with the subject distance from the camera. The farther away the subject, the faster the film rating and vice a versa. With the subject 25-30 feet away, you may start at *f*11 at 1/125. If the subject is less than 10 feet away from the camera, you would need to open up to *f*5.6 at 1/125.

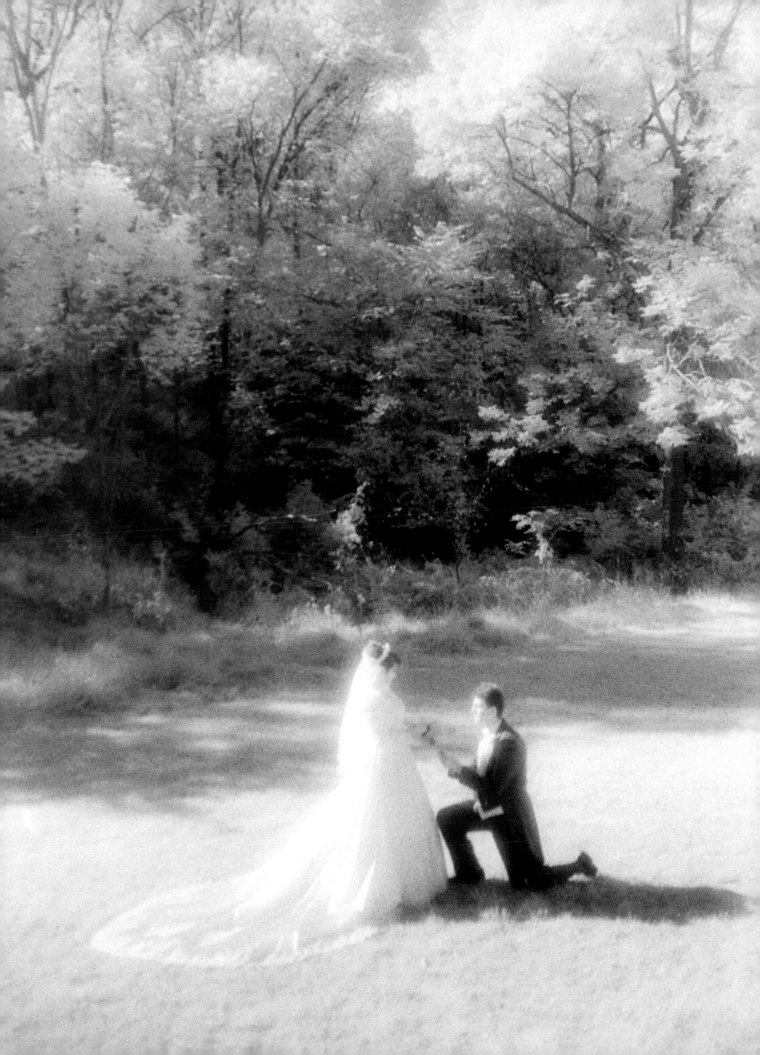

IMAGE 16

Technical Specifications

Travis took this image at a popular gazebo in the Cleveland area. He used a Minolta 35mm camera with a 28mm lens. A number 25 red filter was used in front of the lens. The couple was placed in the sun-lit front of the gazebo and exposed at $f11$ at 1/60 on Kodak infrared film.

The Setting

Travis was looking to capture a casual image of the bride and groom in the gazebo with the infrared film. Patrick took the same photograph with color film, but Travis realized that this image would be much more interesting and striking using infrared film. The bushes in the foreground were bathed in sunlight and glow beautifully in the photograph. The blue sky peeking through the background was rendered very dark and added a nice contrast to the lighter foliage. By giving the couple a choice between a normal color photo and the infrared, the couple better understands the uniqueness and beauty of this special film.

Composition

Travis had the bride and groom inside the gazebo leaning far enough out so that the sun would strike them directly. The lighting crossed the couple from the upper left, giving a light pattern that added depth to the photo. Whenever possible, we try to create a light pattern that provides both highlight and shadow on the subject's face, adding more dimensionality to the image.

The simplicity of the image is what makes it appealing. This is an ordinary photograph with color film, but it took on a different quality when Travis photographed it in infrared. The trees and bushes came alive with the infrared without detracting from the beauty of the gazebo.

Pricing

Our wedding package prices are split into three levels of coverage. The economy level is very limited in the number of images taken and time spent on the wedding day. Neither black & white nor infrared are available in this package. With our intermediate and ultimate wedding packages, the client can have color, black & white and infrared images in their wedding coverage. There is no additional charge for the black & white or infrared — but then again, there is no discount if they just want color images. We want our clients to have albums that are a combination of all three film types because it makes us stand out in our community as the most creative photographers available.

Infrared film is more costly than any other film available. The price for a roll of Kodak 35mm infrared film is between $10-$13 per roll — a significant difference from regular black & white or color film. The developing costs with a commercial processing lab is also slightly higher (in some cases) or the same as developing and printing regular black & white. Add to this the fact that with bracketing you are only getting a few usable exposures per roll — not the entire 36 images. We feel the added costs are a worthwhile investment in making sure our wedding photography is unique and offers something different from our competition. The extra costs have been built into our prices and our clients are willing to pay a little more for something (infrared) that they can not get from another studio.

IMAGES 17 AND 18

Technical Specifications

Travis took both of these photographs during the ceremony at the couple's wedding. This Roman Catholic church allowed for the use of flash photography during the ceremony and Travis was able to move about freely to compose his photographs. Both were taken with a Canon 35mm camera with a 28mm lens and a number 25 red filter in front of it on Kodak infrared film. In the top image, Travis took the photograph from the back of the church on a tripod. His exposure was f4.0 at 1/4. There was no extra lighting utilized for this photo. On the bottom image, Travis moved to the front of the church, and shot with a Vivitar flash attached to the hot shoe of the camera. His exposure was f5.6 at 1/60.

The Setting

Using flash allowed Travis to move in close for a quick "candid" of the best man reading one of the Scripture passages during the wedding (bottom image). He framed the photograph to include the best man, priest and bride and groom. Featuring all of the key people made this a very salable image. For the top image, Travis took the more traditional approach of photographing from the back of the church without flash on a tripod. His exposure was longer and he opened up the lens to get enough light for a proper exposure. Indoors, we rate Kodak infrared film at around 100 ASA/ISO with the red filter in place.

Lighting

When you open up the lens and slow down the shutter speed, you will get considerable overexposure of indoor lighting and any outside light source. In these images, the skylights are a glow of white, as is the highly illuminated statue at the rear of the altar. Candles also glow nicely in infrared and most wedding ceremonies utilize candles as decoration or an integral part of the ceremony.

Classic wedding ceremony images are taken from the back of the church down the center aisle or from the balcony/choir loft. Images from the balcony can be from the center, or off to one side or the other to change the look of the image.

When you are given access to other areas and can utilize electronic flash, we try to move in closer and get interesting moments during the event. We will also shoot back towards the congregation to capture the reactions of friends and family during the ceremony. We never go up on the church altar area and we always try to be as unobtrusive as possible.

Differences in Religious Ceremonies

There are many differences between the different faiths. All Christian wedding (Catholics, Protestants, etc.) have very similar wedding ceremonies. Some of the weddings have a candle lighting ceremony (unity candle) and some don't. Some of them have an exchange of love and peace among the families and some don't.

The biggest difference is that in most Catholic weddings, the photographer can move about the church freely and use on camera flash. In most Protestant weddings, the photographer must stay in the back of the church or balcony and can NOT use flash during the service. In Orthodox weddings and Jewish weddings, the photographer must be aware of the different wedding customs and know to photograph them. In Orthodox weddings, the couples are often "crowned" and are led around the altar three times by the Priest. The icons also play an important role in Orthodox weddings.

In Jewish services, it is important to record the signing of the Catuba (marriage agreement) prior to the ceremony by both the bride and groom. At the end of the ceremony, the groom may step on a glass. These are important events that must be recorded. African American weddings may have the couple "jumping the broom" at the end of the wedding. Some Philipino weddings have a cord and veil ceremony. The key is to understand the customs and know when they will occur during the event so that you are ready to photograph them.

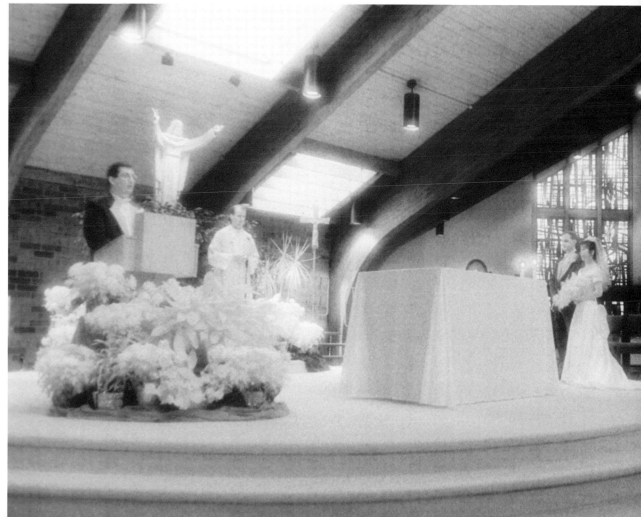

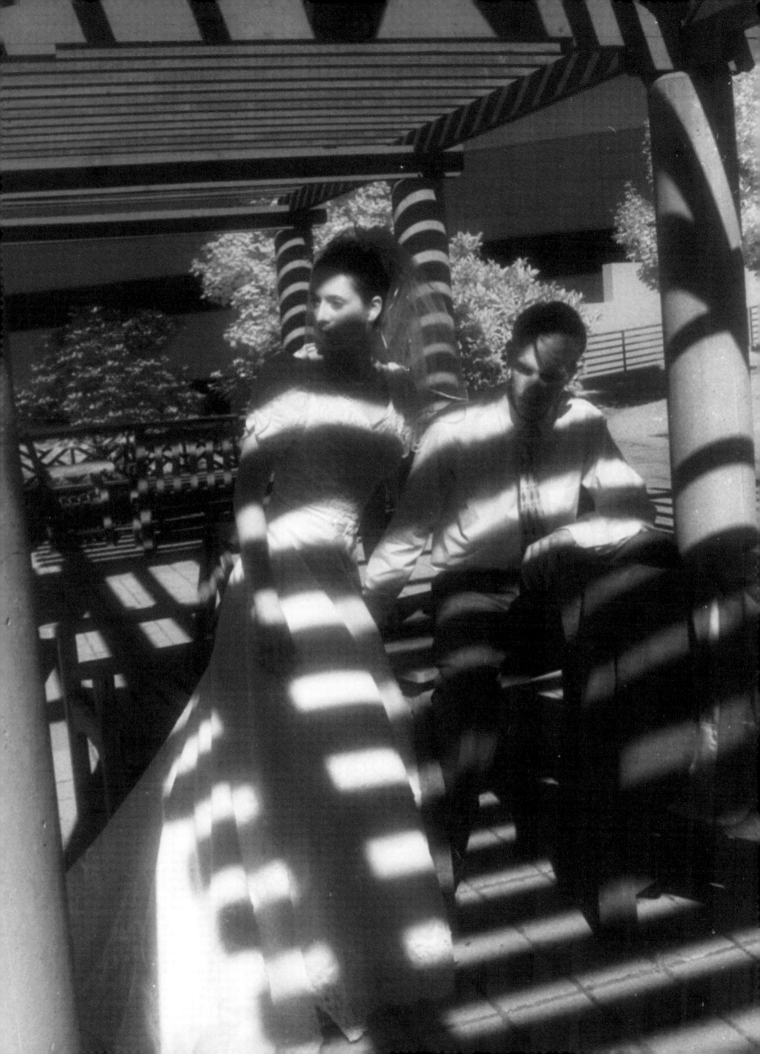

Technical Specifications

This image was taken as part of an instructional seminar put on by a photographic association in Northern Ohio in conjunction with Indiana photographers Jim and Lois Wyant. While everyone else was creating images with color film, Patrick was looking for ways to best take advantage of the infrared film. The photograph was taken with a Minolta 35mm camera with a 29mm lens. A red filter was used in front of the camera lens. The image was exposed on Kodak infrared film at f8 at 1/125.

The Setting

Patrick was looking to create a truly different kind of image. He wanted a very contrasty photograph that allowed him to push the boundaries of the infrared film. The contrast between the light and shadow was magnified with the infrared film. The couple was carefully posed so that their eyes were illuminated by the sun through the beams of this structure. He was really looking for a dramatic art piece more than a typical wedding photograph. So much wedding photography is ordinary and boring, he wanted something that was striking and would grab your attention.

Composition

The natural lighting was very striking in the early afternoon sun and created an interesting pattern that Patrick was trying to exploit. The couple was carefully placed into the scene so that no vertical shadows were obstructing the important aspects of the image. The horizontal shadows were placed across the couple's bodies but not over their eyes. This photograph was taken much closer than Patrick usually takes infrared images because there wasn't a lot of foliage to work with and he wanted the light and shadow patterns to dominate the image.

Lighting

Patrick did not use a light meter for this photograph. We generally don't use one for any outdoor infrared photos. If it is a bright sunny day, we set the lens aperture at f11 and bracket the shutter speed between 1/60 —1/250.

Because the couple was only partially in the light, Patrick opened up the lens one full stop to f8 and bracketed the same way. When we are using infrared film indoors, we rate the film at 100 ASA/ISO and meter accordingly. We rarely bracket indoor infrared images.

Learning & Experimenting

We feel that photographers should know as much as they can about all aspects of photography — not just infrared. This is a constant learning process, and we have only scratched the surface about all there is to know about photography.

A little study in what infrared radiation is and how it is recorded photographically will help the photographer understand what he/she is looking for and just as important, allow him or her to explain this mysterious film to potential clients. The photographer needs to be able to tell the couples more than "this film is really cool." The photographer should be able to explain how it is different and what kind of results they can expect in their wedding images.

Experimentation is the best teacher with all aspects of photography. Whether it is with a particular film, posing, lighting, etc. — the photographer will learn best from doing. Infrared takes some practice to gain the confidence to create consistent quality results. You need to know what to look for and how to make the most of the image.

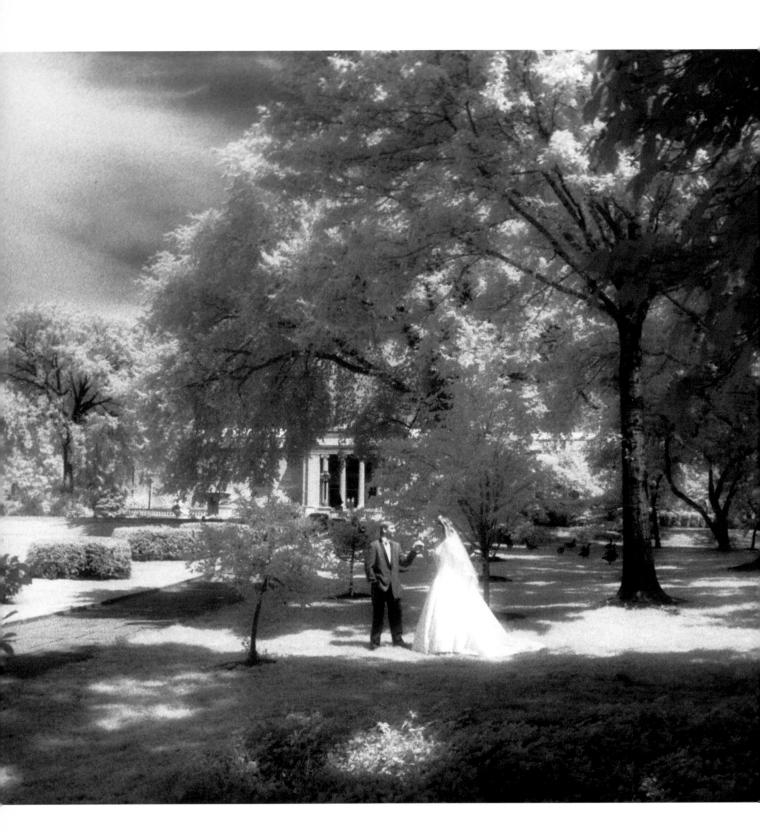

Technical Specifications

Barbara took this image as part of a reshoot for the bride and groom after their wedding day. She took the photograph with a Canon 1N autofocus 35mm camera and a 24mm lens. The lens was manually focussed and had a number 25 red filter in front of it. The exposure was $f11$ at 1/60 on Kodak infrared film. In addition, this photo session was videotaped by Ed and Barbara Pierce for a PhotoVision video series segment.

The Setting

The photograph was taken in the early afternoon on the grounds of the Cleveland Museum of Art. The couple was placed in an area that was open to the sun but surrounded by shaded areas. The Art Museum building can be seen peeking through the trees in the background.

Barbara was trying to create a gallant, somewhat exaggerated pose of the bride and groom holding hands. The hands were held much higher than normal in much the same way is done in formal dances. We believe in chivalry in our wedding photographs.

Composition

Barbara was trying to convey the classic chivalry in the manner in which the groom is addressing the bride and holding her hand. The couple was composed in the center of the frame surrounded by dark shaded areas. In this manner, the couple stands out easily in the image. The extreme contrast between light and shadow is very striking in this image. The trees that are well lit in the background were very light, while those in the shade recorded much darker.

The same is true for the grass — it nearly covers the entire black & white spectrum from very dark to nearly white.

Photo Finish

The finish we use for both the original proofs and finished infrared images is a textured/luster finish — sort of a cross between matte and glossy. Glossy photographs are too reflective for album inclusion and show fingerprints readily. Matte-finished photographs are far more acceptable in albums, but lack some of the punch of a textured/luster finish. We will use matte finish if we choose to selectively hand color a portion of a photograph included in the album. The selective coloring of infrared photographs has been very popular with our wedding clients.

Trying Something New

Some couples are apprehensive about infrared film. People are unsure about anything they do not understand. We first explain what the film is and how it reacts to different lighting conditions and show them specific examples. In one of our sample albums, we have an 8 x 10 color image on one page and the same couple in the same pose shot in infrared on the opposite page. This gives them a visual comparison and helps them see the differences.

Our customers love their infrared coverage on their wedding day. They find these images to be the most unique, most creative and most different than anything they have ever seen. They are excited to see these photographs when they come back from their honeymoon and view their proofs. Infrared images are often the wall prints that our couples will treasure and view every day of their lives.

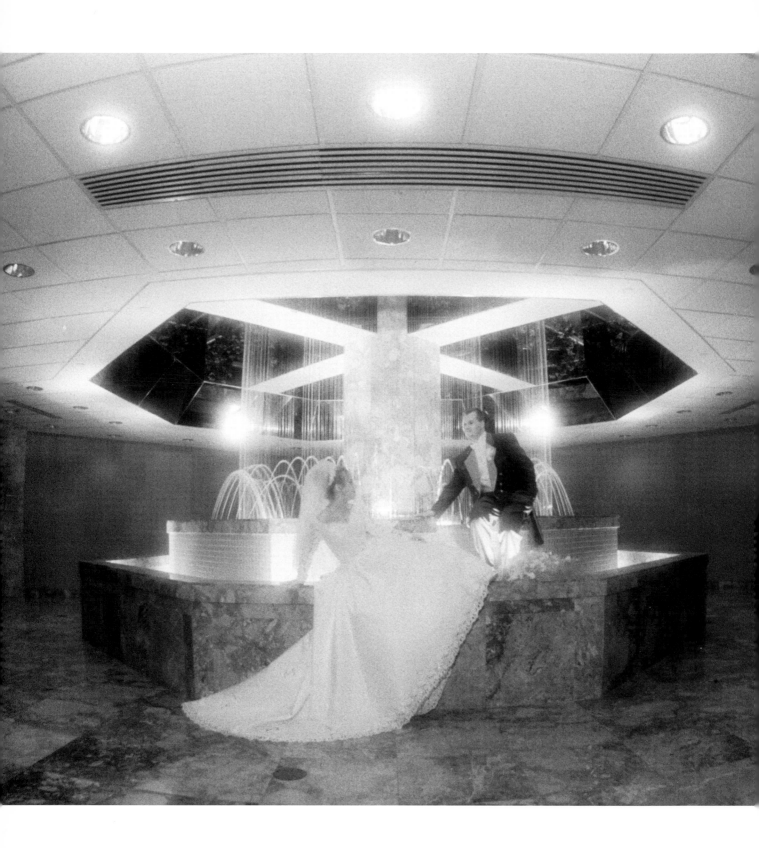

Technical Specifications

Travis used a Minolta 35mm camera with a 16mm fisheye lens. The fisheye lens has a built-in orange filter for use with Kodak infrared film. The photograph was taken on a tripod at $f4$ at 1/8.

The Setting

Travis created this photograph in the lobby of the building in which the bride works during the week. He wanted to capture the beauty of the lobby fountain and the mystery of infrared film for this photograph. In many of our photographs, we have the bride and groom connecting with each other with both their hands and their eyes. This connection adds a realism and intimacy to the images that is sometimes lacking when the couple is looking back at the camera. The mirrors and water spray from the fountain rendered nicely with the infrared.

Composition

Travis decided to compose the image with the couple on the ledge of the fountain in the center of the frame. The fisheye lens allowed him to be very close to the subjects and still record the entire lobby area. He brought out the bride's gown to add flow to the photograph and lead the eye to the subjects. The illuminated water in the fountain made a dramatic infrared image. The lights glowed in the photograph and the pose showed a connection between the bride and groom. The use of the fisheye lens made the area look much larger than it really was and gave the image more appeal.

Lighting

Since Travis was indoors, he rated the Kodak infrared film at 100 and took an incident meter reading of the scene. The lighting was provided by the recessed ceiling lights and the spotlights on the fountain and water. The camera angle was very low so that he would not shoot directly at open lights in the fountain. The lighting was allowed to radiate but not overpower.

Photo Checklist

We have always used a checklist of selected photographs for the bride and groom to fill out prior to their wedding day. This list covers both basic and special photographs and gives both us and the couple an idea about what they are looking for with regard to wedding images. This list is by no means the only photographs that are taken. It is mearly a starting point for the photographer. Photography studios that do not use lists tend to shoot a generic copy of their style of photography — without a lot of input from the couple. (See sample checklist on pages 93 and 94.)

A couple of weeks before the wedding, we sit down with the bride and groom and review the plans for their day as well as the photography. We establish a timeline for the events of the day and make sure the couple understands how long everything takes. By going to this much trouble in the planning and preparation, the couple realizes what they will need to do in order for us to have enough time for the images they want. In most cases, the couples do give us the time we need to create the images they want.

Our couples have chosen us to photograph their wedding because of our creative ability. They know that great images take time to create and they are willing to devote that time to ensure those images can be made. Of course, not every couple gives us enough time. It is in those cases that we concentrate on the most important images and do without the less necessary photographs.

IMAGE 22

Technical Specifications

Barbara created this photograph of the bride and groom on their wedding day between the wedding and reception. The photograph was taken in the midafternoon on a cloudy, gray day. She used a Canon 35mm camera with a 28mm lens. The lens had a red filter in front of it. Barbara exposed the photograph at f5.6 at 1/60 on Kodak infrared film.

The Setting

Barbara was trying to convey the love between the bride and groom with this gentle kiss between them The photograph was taken at the breathtaking Stan Hewit Hall and Gardens in Akron, Ohio. Even though the day was not bright and sunny, Barb was able to create a beautiful and intimate portrait of this couple on their special day.

Composition

Barbara chose to be a great distance away from the bride and groom to enhance the intimacy and candidness of the photograph. She used a low to the ground camera angle to shoot up towards the couple and the building in the background.

Lighting

Barbara is shooting towards the west (the sun) in this photograph. The day was cloudy and mostly gray. There was no color in the sky. Blue skies will appear dark with infrared film, but light gray, colorless skies will remain that way.

Pushing & Pulling Film

Pushing film is the process of overdeveloping (developing the film for a longer period of time than normally recommended) the film to increase its sensitivity and create a denser negative, This process is used when images are recorded on film at less light than the photographer felt was necessary for a quality image. It can be used to expand the effective ASA/ISO or film speed of a particular film. This may be done when shooting in a dark church with slow speed films. Pulling is the opposite of pushing and it is used to effectively lower the speed that the film was shot at. This could be used to compensate for very fast films shot on very bright days outdoors — situations that go beyond the range of the lens openings. We rarely use either technique with any films we use and don't use it with Kodak infrared because we bracket nearly all of our exposures.

Bracketing Exposures

Infrared film does not have a true ASA/ISO. Conventional light meters can only measure visible light. The number 25 red filter blocks almost all of the visible light. For all of those reasons, it is a good idea to bracket your exposures. Experience will give the photographer a feel for what he/she thinks the exposure will be with infrared film, but it is easy to make mistakes when dealing with a nonvisible spectrum. It is far less costly to take a couple of extra exposures (bracket) than to try to recreate a photograph on another day because the photographer made a mistake in calculating an infrared exposure.

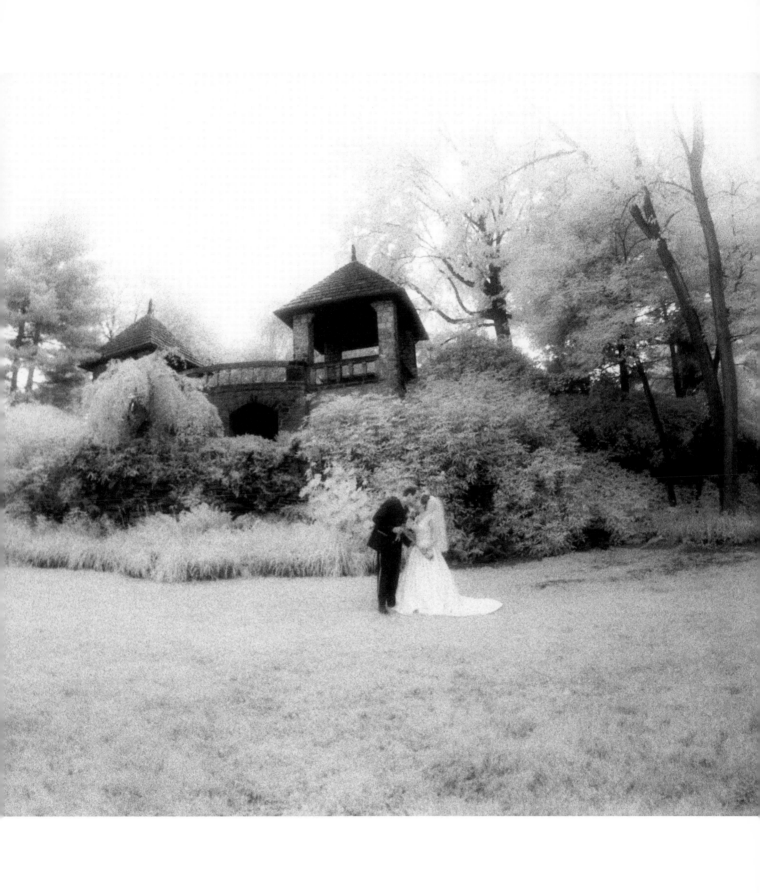

IMAGE 23

Technical Specifications

One of our Associate photographers, Anthony Zimcosky, created this image on a wedding he was shooting for our studio. Anthony used a Canon 35mm camera with a 28mm lens. He had a number 25 red filter in front of the lens. Anthony exposed the Kodak infrared film at $f11$ at 1/60.

The Setting

Anthony was looking to create an image that showed the couple only relating to each other. He wanted a candid looking infrared image. The photograph was taken in a park location not far from the church where the couple was married.

Composition

Anthony placed the couple on the left side of the composition so that the viewer could enjoy not only the posing of the couple, but also the beauty of the surroundings.

Like so many infrared images, the stark contrast between the light and dark areas is very striking. The backlighting of the couple and the glow of the Bride's veil and gown are especially appealing in this photo. The pose of the couple is simple, yet intimate.

Intimate Photos

At Rice Photography, we are known for our natural looking images of brides and grooms. All of us work to create believable wedding photographs that are artistically appealing to our clients. Although we take many images where the couple does pose for the camera, we encourage them to relate to each other — laugh, kiss, kid around, whatever happens naturally. We allow the couples to be themselves on their wedding day.

We often tell the bride and groom to pretend that we aren't there and do what they would do naturally. This is where the best expressions come from. A photographer can create beautiful poses, but they can't create emotion. We can only guide and record what already exists between a loving couple.

Our studio sample photographs and advertisements from bridal magazines can help the couple recreate a pose, but the emotion and love is real and simply allowed to come through on film.

Natural poses can be achieved with ANY couple. The photographer simply needs to allow the couple to relate to each other and not the camera. When a newly married couple looks into each others eyes, there is a look exchanged that is real and natural — it's something you can't ask for or force.

Our couples laugh, kiss or simply get lost in thought. No matter what they do — it is real and doesn't look contrived or posed. Wedding photographers need to stop insisting that couples stare back at their cameras and allow couples to be themselves.

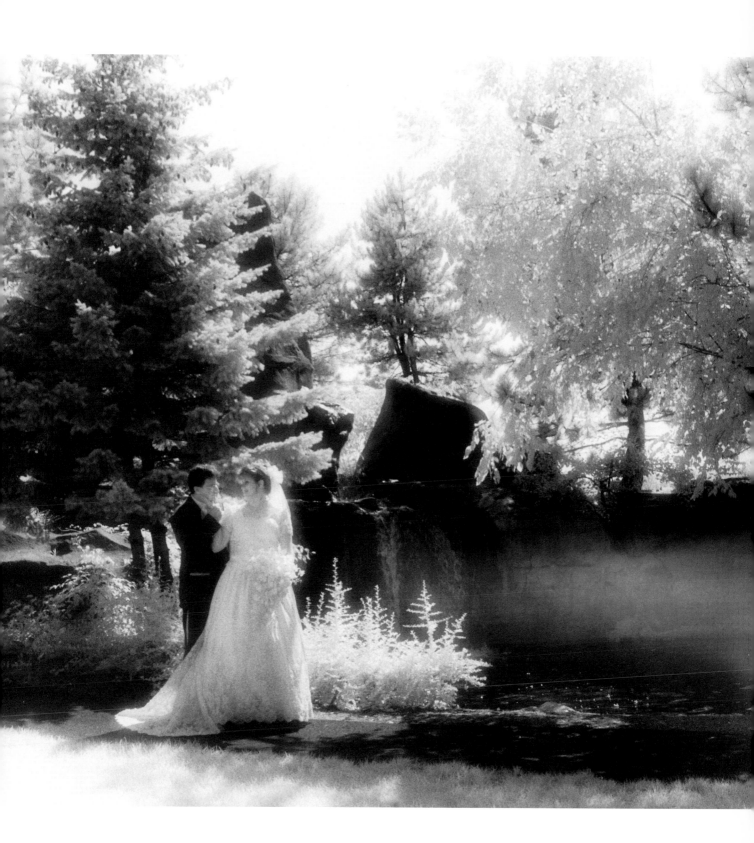

Technical Specifications

Travis took each of these photographs using a Minolta 35mm camera with a 16mm fisheye lens. The fisheye lens had a built-in orange filter for the use with Kodak infrared film. His exposures were f11 at 1/250.

The Setting

Both images were taken in the mid-afternoon at Independence City Hall in Independence, Ohio. Travis chose the fisheye lens to add a dramatic look to the photographs.

Composition

Travis moved around the building to the side for the top photo to give a non-traditional fisheye view of the scene. The distortion of the building is more abstract and the image has a more candid feel to it — it looks less posed because it is no longer symmetrical. For this more abstract approach, the distortion is almost uncomfortable to look at — it has a "Cubist" quality about it. We encourage our photographers to take chances and try different things when they photograph weddings. Even though this image may be too extreme for some people, we like to show our clients (and their friends and relatives when they view the proofs) that we are different and we are more creative than our competition.

He created a symmetrical fisheye image in the bottom photo — with the exception that he chose a very low camera angle and shot up at the building and couple. The building is nicely balanced and the distortion is uniform from side to side. The horizon line is smiling back at the viewer.

The interesting part of these images is that the couple was posed only once, but Travis moved around to create different looking images of the couple.

Retouching

Retouching for any grainy film is trickier than that of sharper films. With negative retouching, you can lighten areas that are darker on the finished print. You can not, however, do negative retouching on light areas of the photograph. The best way to retouch infrared photographs is through digital retouching. With computer software programs like Adobe PhotoShop, you can "clone" information to conceal areas that may be distracting in the photograph. Digitally, you can get an exact duplication of the grain pattern of infrared film that is far easier than pencils, dyes and airbrush (traditional retouching methods).

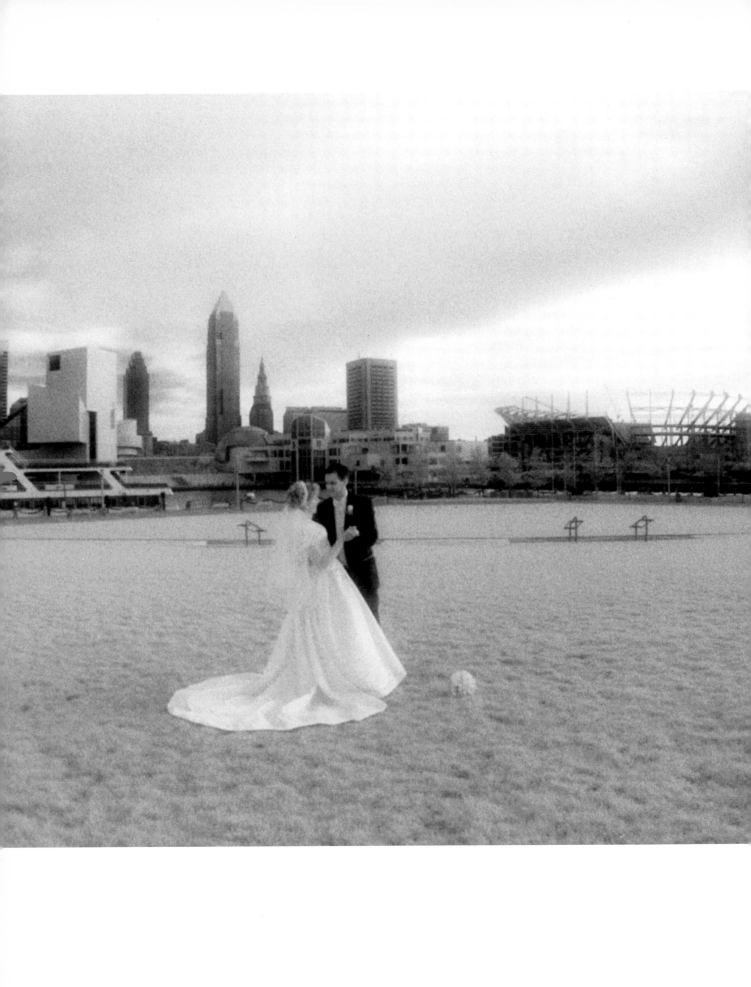

Technical Specifications

Barbara took this photograph of the bride and groom on their wedding day. She used a Canon 35mm camera with a 28mm wide angle lens. A number 25 red filter was used in front of the lens. Barbara exposed Kodak infrared film at f11 at 1/250.

The Setting

Barbara was looking to create a photograph where the bride and groom were dancing with the Cleveland city skyline as the background. This couple wanted images that represented Cleveland and its buildings. The photo was taken in the inner harbor area behind the city on Lake Erie.

Special Photo Requests

When the couples view our samples, they see the variety of poses and the many different locations where they can have their photos taken. They indicate the poses that appeal to them and the sites they like. The couples also utilize bridal magazine advertisements for posing ideas they like. The couples fill out our photograph checklist and write in their special requests on the back side.

On the day of the wedding, anybody can suggest photographs and they will be taken — as long as time permits and we can get all of the images we are committed to take from the list. Usually, the only extra photographs are additional posed group photographs that were not planned for. We will accommodate those requests as time permits.

Developing Film

You can develop your own Kodak infrared film. The developing must be done in absolute darkness with no safelights on at the time. We use D 76 developer for 8½ minutes at 68 degrees, 30 seconds in Kodak stop bath, 4 minutes in Kodak rapid fixer, 1 minute in hypo and 30 seconds with Photo-Flo solution. After the negatives are developed, printing is similar to any other black & white negative.

Burning (making an area darker during printing) and dodging (making an area lighter during printing) can help to enhance the infrared images. Barbara hand printed all the photographs in this book in the darkroom of photographer Scott Gloger of Myron Photographic Elegance, Inc. Because of the extreme contrast of some infrared images, it is sometimes necessary to burn or dodge the images to create a more balanced photograph.

For most photographers, we recommend that you have a commercial processing lab process and proof your infrared film for your wedding clients. It is not cost effective for a studio to print every image from every infrared negative.

A commercial processing lab can produce proof size photographs very economically that you can include with the rest of your clients wedding proofs. Contact sheets are too small for clients to make a determination from and reduce the potential sales to your customers.

IMAGE 27

Technical Specifications

Barbara used a Canon 35mm camera with a 16mm fisheye lens. The lens had a rear element red filter attached to it. Barbara exposed Kodak infrared film at f8 at 1/250.

The Setting

Barbara took this photograph of the couple on their wedding day at Punderson Lake Park. She wanted to create a casual image of the bride and groom. She accomplished this by having the groom remove his jacket and having the bride lean on his shoulder.

The fisheye lens gave tremendous depth to the foreground of the photograph and still included the striking building in the background. It was late afternoon and the shadows are very long and pronounced — adding to the feel of the image.

Lighting & Lens Selection

When the light source (the sun) is very directional (lower in the sky) it creates a spotlight type of effect with the natural illumination. The photographer can take advantage of this by observing the entire scene and paying attention to the play of light. The couple is somewhat backlit with the bride turned away from the direct sun. This effect always is pleasing with the infrared film because the white gown glows.

The lens selection was very important because longer lenses would not record the length of the shadows in the late afternoon sun as well as the fisheye lens does. Fisheye lenses completely change the way you see and record a scene. They are a wonderful tool to use in conjunction with infrared film. We own nine fisheye lenses for our camera systems.

Backgrounds

It is the photographer's job to make the most out of any situation he or she is presented with. Although beautiful backgrounds certainly enhance infrared images, they are not essential. All you need is light. All foliage that is being lit directly by the sun will lighten and turn white. Late afternoon sun is very directional and can be used to your advantage with infrared film. Simply backlighting the bride and groom with the sun will produce dramatic, luminous photographs.

Lens selection can make an ordinary background more interesting. So can changing your camera angle and perspective. Photographers get stuck in a rut, always shooting things the same way. Experiment, take chances, try something new.

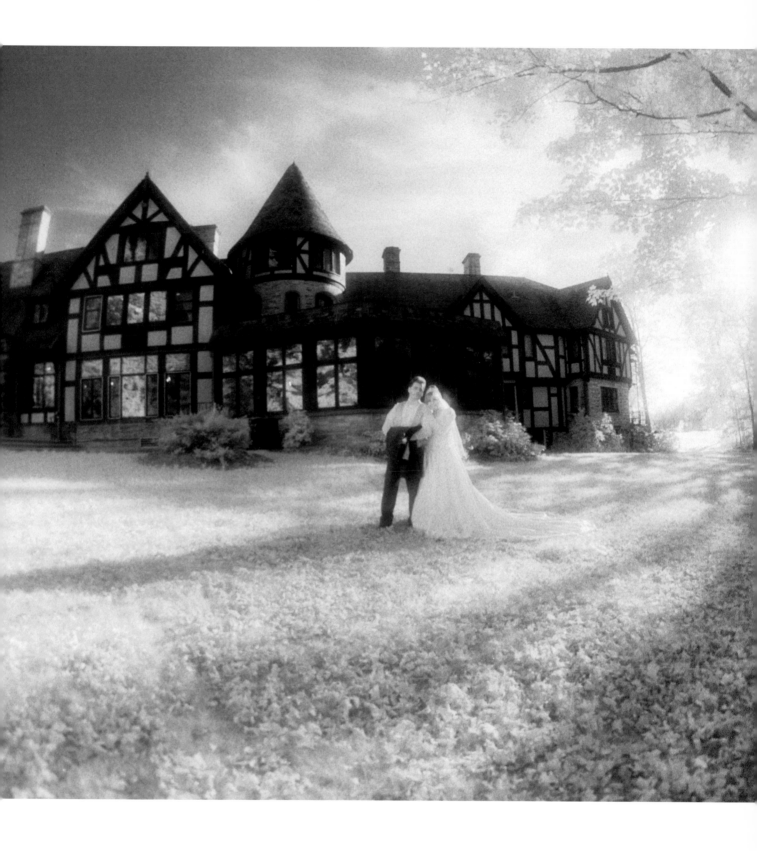

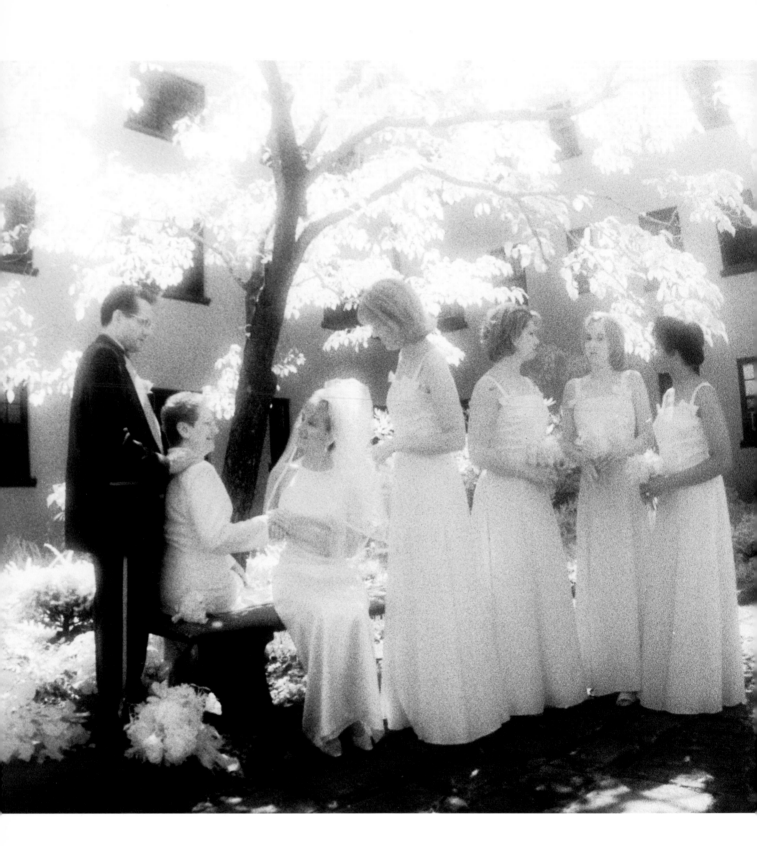

Technical Specifications

Barbara took this photograph of the bride, brides-maids and her parents on the wedding day before the wedding ceremony. She used a Pentex 35mm camera with a 28mm lens. The lens had a number 25 red filter in front of it. Barbara exposed the Kodak infrared film at $f8$ at 1/60. Everyone was in the shade.

The Setting

Like so much of our wedding photography, Barbara was trying to create a realistic, unposed image for the bride. This journalistic style image was set-up slightly by making sure that nobody turned their back to the camera. By having everyone facing in or towards the camera, the viewer feels like they are peeking into a moment on this special day. The pose is not static or contrived, and our clients treasure these images in their finished albums. They also really enjoy creating photographs like these. They know that the finished image will be unique and tell the story of the wedding day in a way that stiff posing can not.

Lighting

This photo was taken in the early afternoon before the wedding ceremony. Barbara took this image in the shade to create a different look than she did of this grouping in the photo on page 28. We try to make the infrared photographs different from each other so that the couple will want to include more of them in their album. If everything looks the same — even with infrared — they will just choose the best image and skip the other photographs.

When shooting infrared in the shade, it is essential to give the image more exposure. This is because there is less infrared radiation in the shade than there is in the direct sun. Infrared images in the shade will also appear grainier than those taken in direct sun, The photos have a softer quality to them.

Working with Groups

As wedding photographers, we are required to take very ordinary group photographs of the entire bridal party and the couple's families. We like to add more interactive images as well to compliment the ordinary images. In this way, our couples have a choice when selecting their album images and they see that we are trying to create interesting photographs on the wedding day.

The most important thing about posing any group is to make sure that everyone is clearly seen from the camera position. People tend to try to "hide" in the back of photographs. As photographers, we must move them around enough so that they will be seen in the image. We create both balanced group photographs and informal group images. In our balanced group photos (on the church altar, etc.) we usually place the bride and groom in the center and evenly split everyone else around them. In our informal groupings, our main concern is that nobody turns away from the camera.

In real life candids, people tend to talk in circles where everyone faces each other towards the center. This does not photograph well since you would be shooting over someone's shoulder and the viewer would feel blocked out of the conversation among the subjects. We open up the subjects and have them looking at each other — usually in profile. This way, the viewer fells like they are part of the conversation with the subjects and the image is more pleasing and inviting.

IMAGE 29

Technical Specifications

Barbara used a Canon 35mm camera with a 16mm fisheye lens. The fisheye lens had a rear element number 25 red filter attached to it. She exposed the image at $f8$ at 1/60 on Kodak infrared film with the couple in the shade.

The Setting

Barbara created this photograph for the bride and groom on their wedding day between the ceremony and the beginning of the reception. This image was taken at midafternoon at the beautiful Stan Hewit Hall and Gardens in Akron, Ohio. Barbara was looking to create a dramatic image of the bride and groom in the courtyard of this wonderful location. She used the fisheye lens to add feeling and drama to the final image. The lens brought the trees and railing in towards the bride and groom. In this image, everything leads the viewer's eye to the couple. They are placed in the center of the image and they command your attention.

Lighting

Barbara wanted to emphasize the contrast between the very bright background foliage and the subtle deep areas of the courtyard. She posed the couple in such a way that we can still see their features, but they stand out very dramatically by the overlit background. Because the couple is in the shade, she gave the image more exposure — thus blowing out most of the details in the background. This effect keeps the viewer from being overly distracted by the background.

Preparing Equipment

We prepare for a wedding by first reviewing the couple's checklist of photographs for their wedding day. We determine what film types we will be shooting for their wedding. We make sure we have the necessary directions to wherever we need to meet them and emergency phone numbers in case we run into problems finding them. We clean and check all of the cameras and lenses. We make sure the batteries are charged and ready. We are overly cautious. Our equipment is brought in for routine cleaning and inspection often. We carry substantial backup cameras, flash guns, cords, film, batteries, etc. You never know when something might stop working — it is better to be prepared.

The equipment that every wedding photographer "must have" includes the four lenses mentioned below (normal, wide angle, portrait and fisheye) plus: at least two matching flash guns with more than enough batteries to make them fire; a sturdy tripod; a radio slave for backlighting and double lighting images; a solid camera case large enough to carry your equipment (we each carry at least three cases to each wedding), and an emergency supply kit. The emergency supply kit should be a case that contains miscellaneous items for both you and bride and groom. Our kits contains extra batteries for both cameras and flash units, extra cords and connecting cables, safety pins, hair pins, straight pins for pinning on flowers, a lint roller, Shout® wipes for quick cleanups, a sewing kit, aspirin and other items we have learned to bring along on the wedding day. We have "saved the day" numerous times by having these inexpensive items handy for the bride and groom when the need arose.

Lenses for Wedding Photography

We feel that every photographer needs at least four lenses: a normal lens (50mm in 35mm format and 80mm in medium format); a wide angle lens (anything between 24mm-35mm in 35mm format and 45mm-55mm in medium format); a portrait lens (90mm-135mm in 35mm format and 120mm-150mm in medium format), and a true fisheye lens. We feel the fisheye lens is one of the most distinguishing features of our wedding photography. Very few studios own a fisheye lens and even those that do are reluctant to use them in their wedding coverage. A fisheye lens can change the look of your photography instantly. Our clients love it.

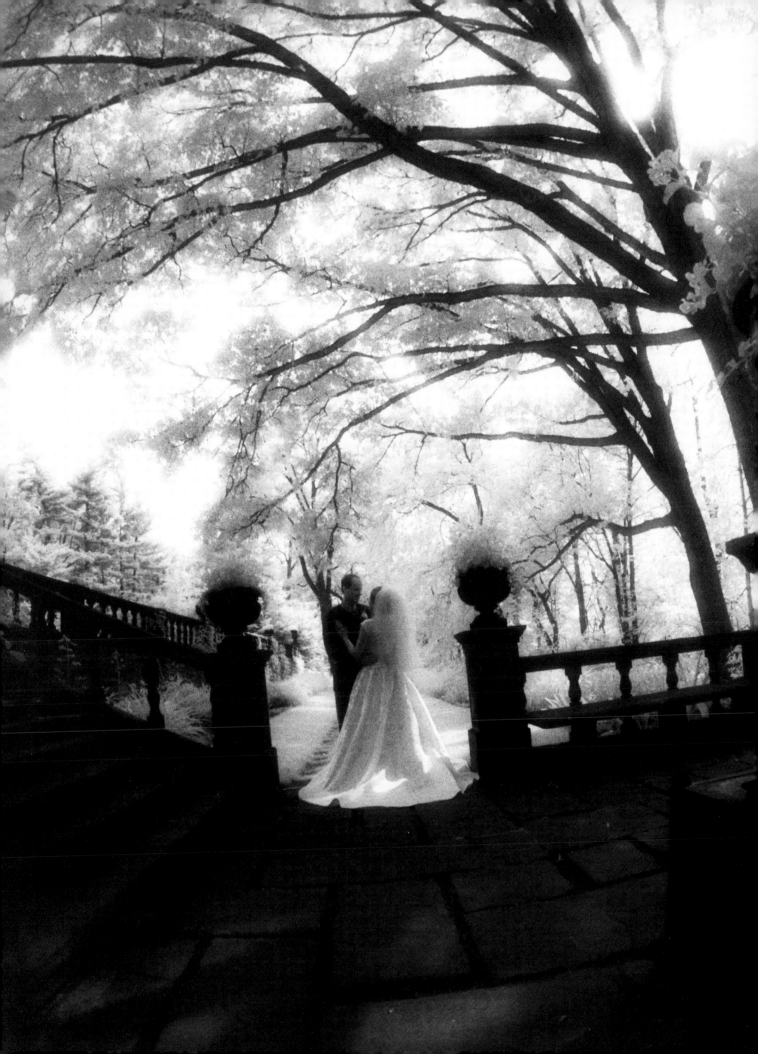

IMAGE 30

Technical Specifications

Barbara used a Canon 35mm camera with a 28mm wide angle lens. The lens had a number 25 red filter attached to it. Barbara exposed the Kodak infrared film at ƒ4.5 at 1/60. The photograph was taken very late in the afternoon as the sun was going down.

The Setting

This image was taken of the bride and groom just before they entered the country club where their wedding reception dinner was going to take place. Barbara wanted to create a simple image of the bride and groom in the entranceway to the country club to give the couple a permanent reminder of where they had their wedding reception dinner. She chose to use Kodak infrared film to make an ordinary photograph a little more interesting. The infrared renders the scene much differently than it looked in color and made the final print much more artistic and appealing.

Conduct at the Reception

The rules we follow at the wedding reception are, more than anything, "common sense" issues. We do usually eat at our weddings. This is because we have built a relationship and friendship with our couples prior to and throughout their wedding day. We are looked upon as friends, not just hired photographers. The couples invite us to join them for dinner at their receptions. After the toast, blessing and first kiss by the bride and groom, there really aren't a lot of things that need to be photographed until after the reception events start happening (i.e. cake cut, dancing, etc.). Drinking is certainly an area where the photographer should use common sense. We feel it is improper for the photographer to be walking around with a beer in his or her hand. However, a glass of wine or sip of champagne with the meal is not unacceptable. Again, good judgement and common sense should prevail.

Working with the Bride & Groom

Our brides are generally VERY helpful when it comes to the photography on their wedding day. This is because we have gotten the bride and the groom excited about the wonderful images we will be creating *with* them — not *for* them. We feel this is a joint process — it takes a team effort of the couple and the photographer to get spectacular results on film.

We try to deal with both the bride and groom with the same respect and attention. With many photographers, the groom is virtually ignored and his wishes are not even considered. We want both the bride and groom to be involved in the planning of the photographs so that they are both happy and enthusiastic about the end results. This philosophy has proven very profitable and made our wedding days a pleasure to photograph.

When a bride or groom seems uninterested, it is because we didn't get an opportunity to fully explain the process of how we create memorable images. This only happens when one or the other lives out of town and we don't get an opportunity to meet and talk prior to the wedding.

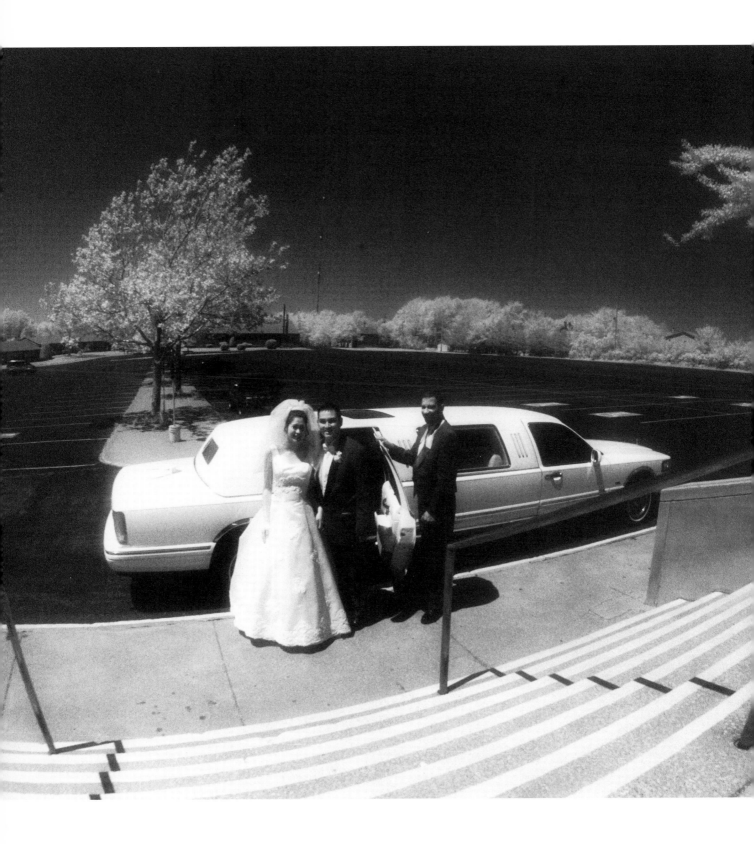

Technical Specifications

Travis used a Minolta 35mm camera with a 16mm fisheye lens. The fisheye lens had a built-in orange filter. He exposed Kodak infrared film at f11 at 1/250.

The Setting

Travis took this image of the bride and groom as they were about to enter their limousine to go to the reception. This is a very common wedding day photograph of the bride and groom. While Patrick was taking the same picture with color film, Travis decided to shoot the image with the Kodak infrared and a wider lens. The limo was parked just in front of the church and the rest of the bridal party was already in the car.

Composition

Travis simply had the couple look back towards him and recorded the image. His ultra wide lens recorded all of the stretch limo and created some interesting distortion of the steps. Travis shot down on the subjects to pick up more of the foreground. This photograph is strengthened by both the perspective and lens selection. Travis did a wonderful job of taking an ordinary photograph, and making it far more interesting. Like so many of our images, we are always looking to view the shot from a different perspective and camera angle. The high angle of this image is very effective. The lens selection also adds to the interest of this image. The fisheye lens made the limo look longer than it really was and it brought all of the elements of the scene around the bride and groom. The dark skies offset the stark white car very nicely.

Uncooperative Couples & Families

Uncooperative couples and/or families are a challenge to every photographer. We don't usually have this problem, but when we do, we simply try to get every image they want in the least amount of time. Most uncooperative couples and/or families simply don't want to spend the time required to create great wedding photographs. Besides the essential family group images, we may simply take an all-journalistic approach to photographing their wedding day. By this we mean that we would use longer lenses, faster film and try to capture the feeling and emotion of the day without actually engaging the couple or their families and guests.

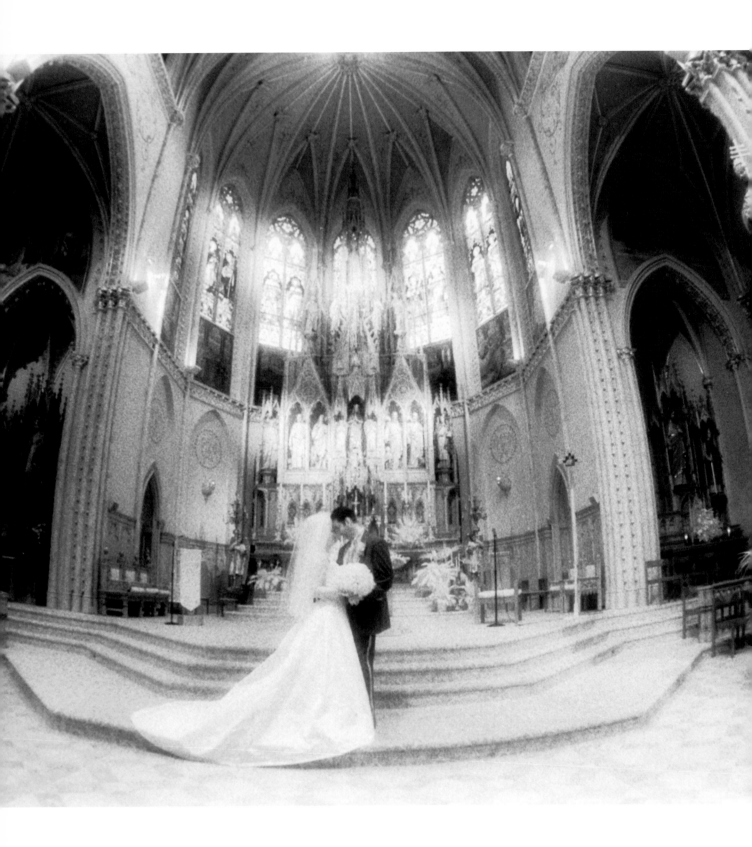

Technical Specifications

Patrick used the Mamiya 645 Pro TI camera with the 35mm film back loaded with Kodak Infrared film. He used the Mamiya 24mm fisheye lens with the built-in orange filter. The camera was on a tripod and the exposure was ƒ4 at 1/4. All of the illumination was from the lights and windows in the church.

The Setting

Patrick took this photograph of the bride and groom just after their wedding ceremony at Saint Stanislas Church in Cleveland, Ohio. This old church was built by hand by Polish immigrants nearly 100 years ago.

This particular couple had seen, in Patrick's studio samples, a similar photograph with color film that he had done with another couple at this same church. They loved the photograph and wanted one like it. He took the color photograph of the bride and groom, and then switched film backs on the Mamiya camera to create the same shot in infrared. In essence, he gave them exactly what they wanted and expected, but also gave them another different yet equally beautiful photograph. They loved them both.

Composition

With much of our photography with the fisheye lens, Patrick was trying to create a symmetrical photograph of the front of the church with the bride and groom being the center of the frame and the center of attention. He took a low angle with the camera on a tripod and shot up towards the bride and groom.

The fisheye lens always has an interesting and dramatic effect on any photograph. Its ultra-wide field of view allows the viewer to enjoy much more of the scene than is possible using other lenses. The distortion created by the fisheye lens makes an exciting rendition of this and most other scenes. The image feels like it is being "drawn in" by the love of this bride and groom.

Infrared Differences

With indoor infrared photography, you get a different look to your infrared photographs than you do with when the film is shot outside. The film is grainier than most "regular" black & white films.

One of the biggest differences is in the way that incandescent lights inside the church, and windows to the outside are rendered with infrared film. These light sources luminesce (glow) much more with the infrared than traditional black & white film.

The satin in the tuxedo still reflects enough infrared light to look lighter in the photograph with infrared film. Any foliage indoors that is being illuminated sufficiently will still record much lighter in color than normal.

Images 33, 34 and 35

Technical Specifications

Travis took the top two photos and Patrick took the image on the bottom. All three images were taken on Kodak infrared film. Travis' images were exposed at $f4$ at 1/4. He used a Minolta 35mm camera. In the middle image, he used a 28mm lens with a red filter in front of it. For the top photo, Travis used a 16mm fisheye lens with the built-in orange filter. Both of his photographs were taken on a tripod and were back-lit with a Metz flash unit fired by a Quantum Radio slave. The flash was set on $f5.6$ on automatic. Both of these photographs were taken on the day of the wedding for these two different couples.

For the bottom image, Patrick used a Minolta 35mm camera with a 28mm wide angle lens on a tripod. He took a very low camera angle and exposed the Kodak infrared film at $f4$ at 1/2. He used a Metz flash unit to backlight the couple for this image. A Quantum Radio slave set off the flash set at $f5.6$ on automatic. For this image, we were working with fellow photographers David and Robert Neldon on this couple's wedding day. While they shot images in color, we used infrared film.

The Setting

These photographs were taken at the world renowned Cuyahoga County Courthouse in Cleveland, Ohio. This building has been the background for Hollywood movies including *Air Force One*, starring Harrison Ford. It is the most popular indoor location in the area for wedding photographs. The stained glass was donated to the city of Cleveland by France when the building was being constructed and spans two stories of the building.

Composition

We always try to give our couples different images than what we have done before. Although shot in the same location, each of these images is a little bit different. In the top photo, Travis chose to use the fisheye lens with the infrared film, while in the middle image, he used a 28mm wide angle lens. For the bottom photo, Patrick used the same focal length lens that Travis had in the middle photo, but Patrick chose to use a much lower camera angle than Travis did.

The poses are also somewhat different in each photograph. Travis posed his couples using wedding dress advertisements that he had seen in bridal magazines. The extra exposure that Patrick gave in the bottom photograph really made the stain glass window glow in the final infrared photograph.

Differences in the lighting for these photos will depend on the time of day that the image was taken and how bright the sun is shining through the stain glass window. The incandescent illumination is always the same inside the building, but the intensity of the light from the window changes.

Indoor & Outdoor Equipment

We do not change our filters in front of our lenses whether we are shooting infrared film indoors or outdoors. We rate the infrared film at 100 ASA/ISO indoors, so it is necessary to provide the infrared film indoors with enough light to render a quality image. We can do this by using a tripod and slowing down our shutter speed, using a flash on camera, or both.

For images at the Cuyahoga County Courthouse, we do not utilize a flash on the camera to illuminate the subjects. We prefer to use a tripod, open up the lens and slow down the shutter speed. We also enjoy backlighting the bride and groom in many of our images and this is accomplished by using a flash attached to a radio slave unit. We usually use Metz flash equipment and Quantum Radio Slaves to trigger the flash. We do not use flash outdoors with our infrared film — we prefer to utilize the natural illumination falling on the subjects. We will use reflectors outside if we feel it is necessary to add some light back on the bride and groom.

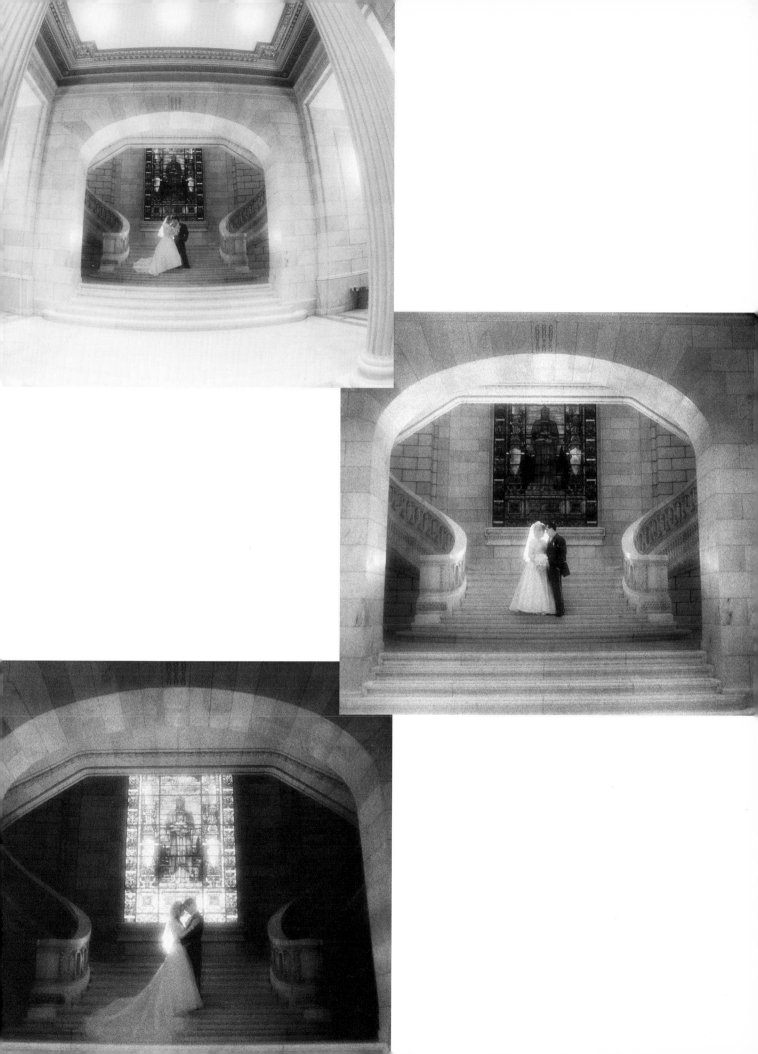

IMAGE 36

Technical Specifications

Barbara used a Canon 1N autofocus 35mm camera with a 24mm wide angle lens. She shot the image in the manual mode and used a number 25 red filter in front of the lens. The exposure was $f11$ at 1/250.

The Setting

Barbara took this exquisite photograph of the bride and groom several weeks after the couple's wedding day as part on the instructional video we produced with Ed and Barbara Pierce for their *Photo Vision* video magazine series. The image was taken at the Cleveland Museum of Art on a sunny afternoon.

Composition

Barbara posed the bride and groom on a railing in front of the pond on the grounds of the Cleveland Museum of Art. The pose was meant to create the interconnection between the bride and groom.

The groom has his back to the camera and he is posed in back profile, where the bride is turned toward the camera and is posed in front profile. Their outside arms are extended out from their bodies to create diagonal lines that lead you into the subjects and form a triangle at their heads. Their inside arms are interlocked to show the love and closeness between them. The foliage illuminated nicely with the mid-afternoon sun. The contrast between the dark railing and light trees was mirrored by the contrast between the groom's tux and the bride's dress.

Digital Infrared Cameras

We have not yet had the opportunity to try any of the digital infrared cameras. However, we believe that as digital cameras become more sophisticated and file sizes and image quality increases, digital photography will take over the bulk of all aspects of photography. It is not that traditional methods of recording an image will completely go away, it is simply that digital cameras will become the tool of choice for image capture.

At this point, there are many exciting things that we can do with digital manipulation and restoration of images. Digital capture is either too costly or not of a good enough quality to have taken over the market to this point. When the equipment improves and the price of the cameras drop, you will see more and more photographers getting on the digital photography bandwagon.

Color Infrared

Barbara has much more experience with color infrared than Patrick or Travis. The newer color infrared is now an E6 process, where the original could only be processed in a couple of places in the country.

The biggest problem with color infrared film is that is a slide film, not a print film. Making prints from slides is somewhat expensive and we show our clients paper proofs not slide previews.

For those reasons, we do not include color infrared film in our wedding coverages — at least not yet. In color infrared film, you use a yellow filter over the lens. The grass and foliage are rendered magenta on the slide. It is known as "false color" film because the colors in the scene are very different than they are in real life.

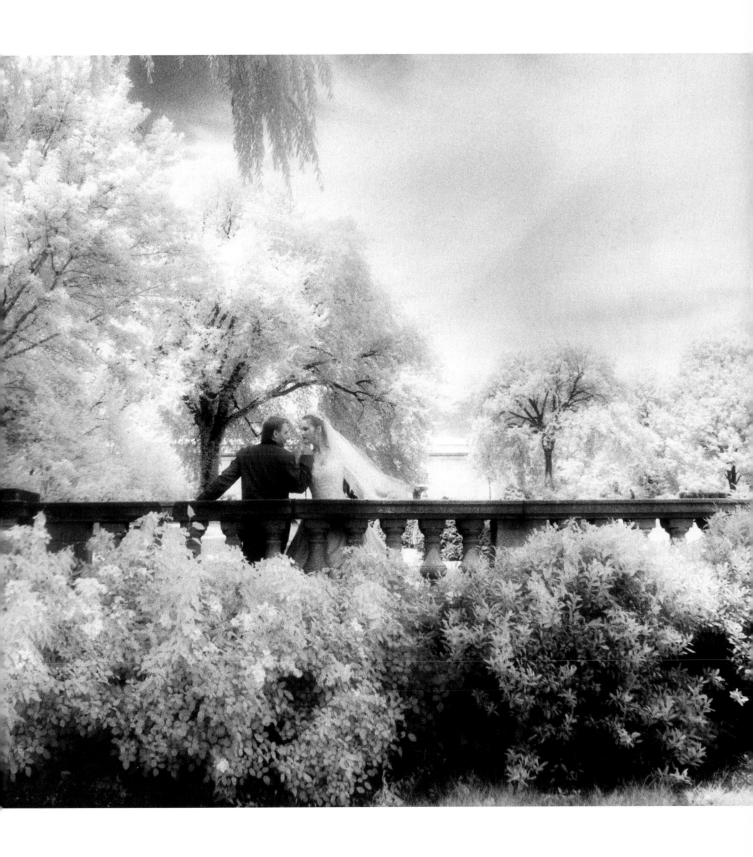

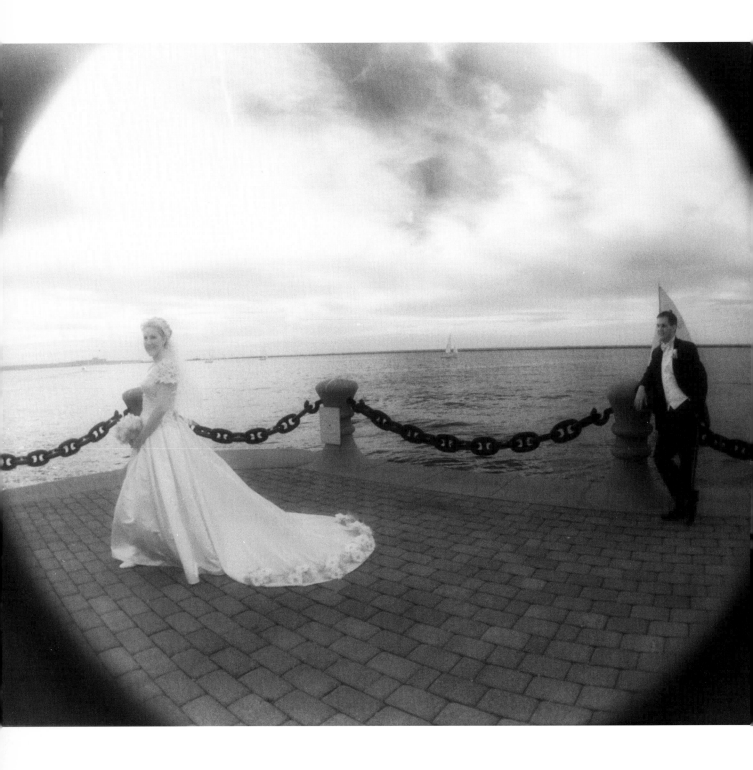

Technical Specifications

Travis used a Canon 35mm camera with a 16mm fisheye lens. The lens had a rear element number 25 red filter attached to it. He exposed the Kodak infrared film at $f11$ at 1/250 on a bright, sunny afternoon.

The Setting

Travis took this image on the couple's wedding day after the ceremony and prior to the start of the wedding reception at the city of Cleveland Inner Harbor park.

Composition

Travis wanted a different kind of photograph of the Bride and Groom. Most images that show a married couple have them standing next to each other. This one is different. Again, from utilizing Bridal magazine dress advertisements, Travis chose a pose where the Groom was apart from his Bride and simply admiring her from a distance. The Bride is still making eye contact with the camera to provide the viewer with a visually connection to the image. It is very common in advertising images to have one subject looking back at the camera, while the other subject is completely involved in the feeling of the image. For this particular photograph, Travis took the bold approach of leaving the lens hood on the lens and allowing it to vignette the corners of the photograph. By doing so, you get the feeling you are staring into the frame and peeking into a private moment between the bride and groom.

Lens Selection

Travis chose the fisheye lens for this photograph to add some interest to what could have been an ordinary wedding photograph. Shooting at this location, there was not a lot going on with regard to the background, so it was essential to pose and choose the lens carefully to make the image interesting.

Our clients love the use of the fisheye lenses we own — whether in color, black & white or infrared. These lenses let you see the world in a way that can not be viewed any other way. They create a fascinating view of the surroundings and allow you to enjoy far more of the scene as it has been recorded on the film. We feel fisheye lenses are an essential part of our wedding photography and our clients agree.

Mamiya Fisheye ULD C 24mm/f4 lens.

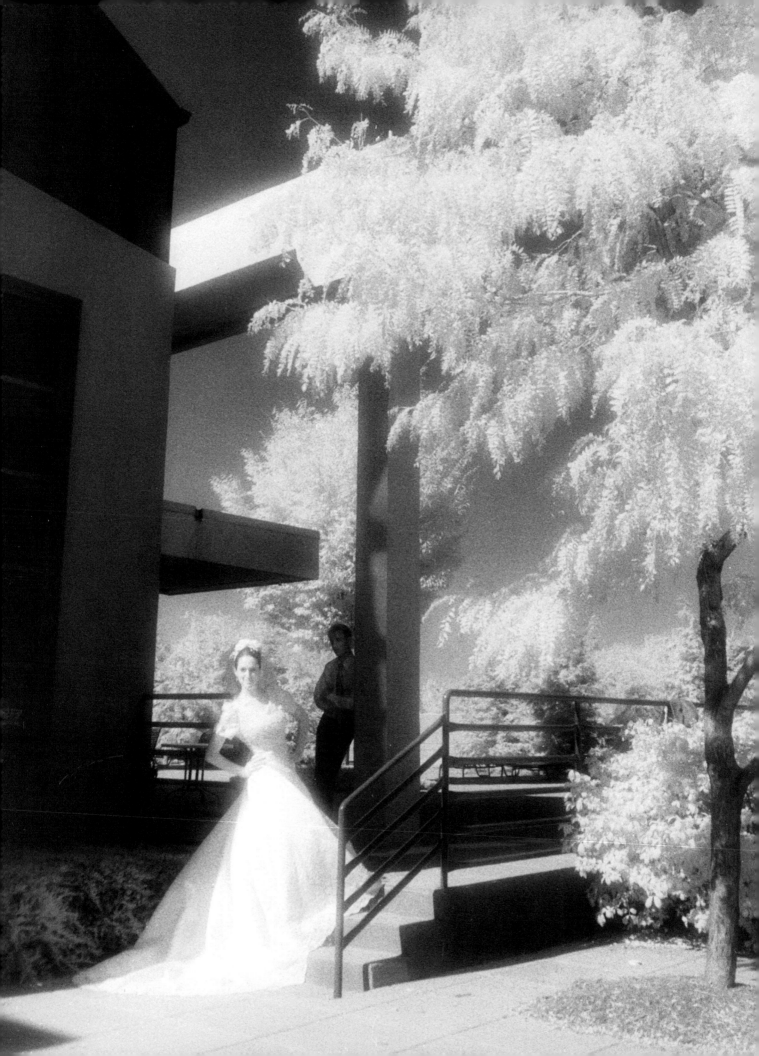

Technical Specifications

Patrick used a Minolta 35mm camera with a 28mm wide angle lens. The lens had a number 25 red filter mounted on the front of it. The exposure was $f11$ at 1/250.

The Setting

This image was created on a photo shoot with fellow photographers Jim and Lois Wyant on the campus of the Medical College of Ohio in Toledo, Ohio. While Jim and Lois were shooting color and regular black & white, Patrick was shooting Kodak infrared.

Composition

The key with this image is to play on the stark contrasts — whites and blacks, highlights and shadows, building and trees, bride and groom. The bride is in a very exaggerated pose — sort of twisted back to the camera. It is a fashion shot of the bride. The groom, on the other hand, is left in the background in an almost uninterested pose. The bright sun richly illuminated the bride and the foliage, while the deep shadows barely reveal the building and the groom. The compositional elements were placed in the frame in such a way as to balance each other out. The white foliage on the right is balanced by the deep shadows of the building on the left. The brightly illuminated bride is contrasted by the groom who is barely distinguishable in the shadows. Patrick entitled this photo, "Opposites Attract."

Previsualizing Infrared Photos

Barbara, Travis and Patrick all previsualize images to some extent. Our experience has taught us what to look for and more importantly, where to place people in the composition when using infrared film. Knowing that the groom in this photograph would stand out from the foliage when it recorded very light in color was important in the the subject placement. Previsualizing is something that does truly come with experience. You will gain confidence with every role of infrared film that you shoot. We are always experimenting and always learning, but we certainly are not "guessing" when it comes to creating great infrared wedding photographs.

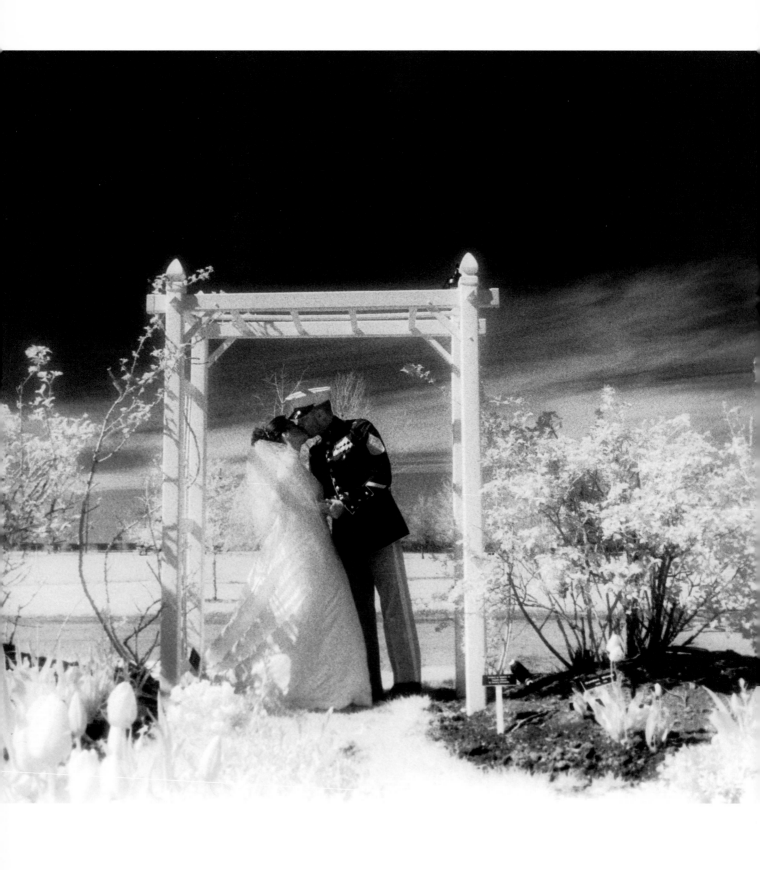

Technical Specifications

Barbara used a Pentex 35mm camera with a 28mm wide angle lens. The lens had a number 25 red filter on the front of it. Barbara exposed Kodak infrared film at $f11$ at 1/250.

The Setting

Barbara created this photograph of the bride and groom on their wedding day after their ceremony and prior to their reception. It was a sunny afternoon at the rose garden at Cahoon Park in Bay Village, Ohio.

Barbara wanted to record an intimate moment between the bride and groom on their wedding day. The simple kiss between the couple showed their love and affection. The rose garden provided a unique background for the image and the rose bushes glowed nicely in the photograph.

Composition

Since Barbara was utilizing a very symmetrical structure (the arbor), she created a very symmetrical portrait of the couple. Placing the bride and groom in the center of the frame allows the viewer to move around the image, but always come back to the focus on the couple. This photograph was entitled, "Private Kiss" alluding to the secluded feeling you get when you view an image like this, and playing on his rank in the U.S. Marine Corps.

Wall Portraits & Frames

Very often, we will have our clients choose an infrared image as their wall portrait. Infrared images are seen by our couples as more than mere wedding pictures, but rather works of art. When you use any grainy film that is intentionally grainy (like Kodak infrared) the bigger you enlarge the photograph, the more artistic it looks. We celebrate the grain in the film and consider it one of the biggest selling points to infrared film with our clients. It takes on an almost "Monet-like" quality as it is enlarged.

We also offer frames for our infrared wall prints. Offering frames is important because the choice of the right frame will absolutely enhance the infrared image. Furthermore, only certain types of frames work well with infrared images. We prefer frames that have a pewter color accented in black. The infrared images look great in these colors. Excel Picture Frames, Inc. offers several frames in standard sizes that work very well with infrared images. We keep some of the styles and sizes in stock to try to sell the frame as an add-on purchase right as the couple is picking up their finished wall print. This is much easier than selling from frame corners or from a picture in a catalog.

Images 40 and 41

Technical Specifications

Travis took both of these images of the couple on their wedding day after the ceremony and prior to their reception. He used a Canon 35mm camera with a 28mm wide angle lens. The lens had a number 25 red filter attached to the front of it. Travis exposed the Kodak infrared film at f11 at 1/250.

The Setting

Travis learned that this restored classic automobile belonged to the bride and groom and it was very important to both of them. He decided to use the car as a posing prop for the images. In the top photo, he took a high angle and shot down on the bride and groom. For the bottom photo, he moved around to the front of the car and took a low angle and shot up at the couple.

Differences Between the Photos

Although there are only slight differences in the posing of the couple, Travis changed the images dramatically by changing his perspective when he took these images. In the top photo, Travis stood on a table to shoot back down on the couple and their car. He shot with them just right of center to add some dimension to the car. For the bottom photo, Travis layed down on the ground and shot up at the couple from the front of the car. By doing this he made the car look more dominant and was able to record the detail in the front bumper and grille.

The sky is darker in one image than the other because as Travis changed his camera angle, he changed his position with relationship to the sun. When you shoot with the sun at your back, the sky will appear darker than when the sun is crossing the image from the side or you are shooting towards the sun.

Additional Photo Sessions

In about 15 % of the time, we schedule a photo session with the couple apart from their wedding day. This is usually after the actual wedding so that the bride is not concerned about getting her wedding gown dirty prior to the actual wedding day. Any dirt that the bride gets on her dress during the wedding day is unlikely to show up in the photographs in our sessions following the wedding day.

We rarely schedule a session with just the bride prior to the wedding day. This practice of creating the "bridal portrait" before the wedding is still popular in some parts of the country, but it is usually a formal studio photograph — not an image taken outdoors.

Typical Wedding Coverage

Most of the images we take of the bride and groom are after the wedding and prior to the beginning of the reception. We typically have a 1-4 hour gap between the end of the ceremony and the time at which the bride and groom need to arrive at the reception site. Some reception sites have beautifully manicured grounds, so we may take some outdoor images throughout the reception as the lighting permits. Sometimes we have afternoon luncheon receptions and we do the outdoor photographs following the end of the reception since it is still light outside.

A typical wedding day begins when we arrive at the bride's parents' home 2-3 hours prior to the wedding for some photographs. From there, we head off to the church and get a few pictures of the groom before the ceremony begins. The most common start time for our wedding ceremonies is between 12:00-2:00. Naturally, we photograph the ceremony as it happens and we take family group photographs on the church altar after the ceremony. After we leave the church, we usually go to a park location or an indoor location (like the Cuyahoga County Courthouse) for more images of the bride and groom and the wedding party. We arrive at the wedding reception and photograph the formal and candid events as they unfold before us. We spend 10-12 hours with the bride and groom on a typical wedding day.

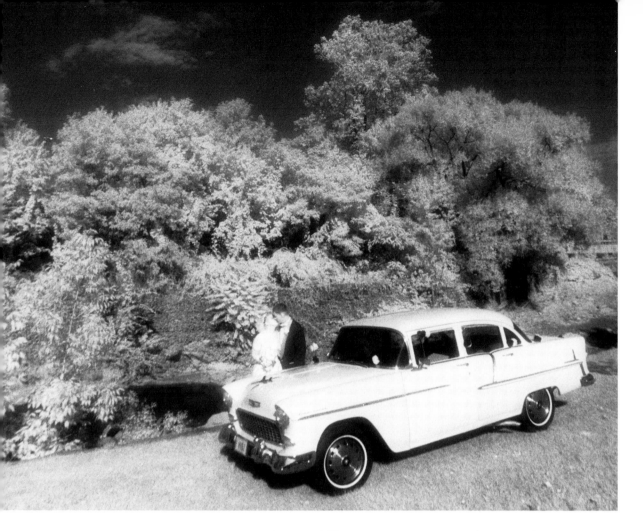

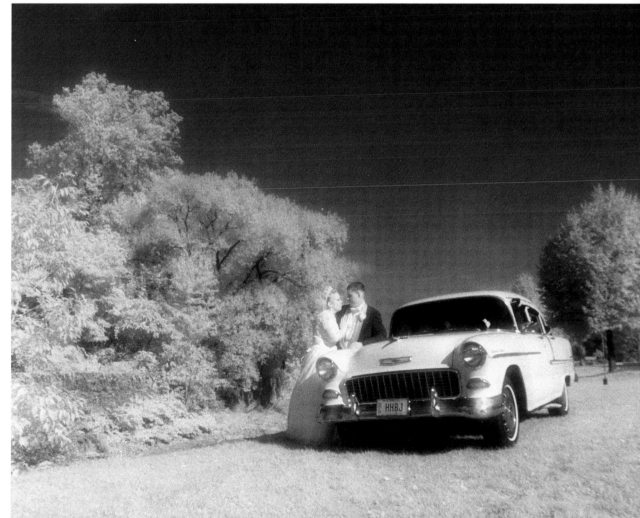

IMAGE 42

Technical Specifications

Patrick took this photograph from the back of the church during the couple's wedding ceremony. He used a Mamiya 645 Pro TL camera with a 35mm camera back and a 55mm wide angle lens. The lens had a number 25 red filter attached to the front of it. He exposed the Kodak infrared film at ƒ4 at ½ with the camera on a tripod.

The Setting

Patrick wanted to create an interesting candid image of the couple exchanging their vows on their wedding day so he took this photograph with both color film and black & white infrared. The infrared image created an intriguing look with the lights and windows glowing brightly and the rest of the interior of the church rendering much darker. The lighting really draws the viewer's attention to the couple on the altar area.

Composition

This photograph was composed from the back of the church with the camera on a tripod about four feet in the air. After Patrick took this photograph in color, he switched to his 35mm camera back that was loaded with infrared film and took this image. It made an ordinary image very interesting and different than what was expected.

Artificial Indoor Light

Different artificial light records differently with infrared film. This is due to the differences in the "color" and color temperature of the light. Some light sources have more infrared radiation than others. Flash and strobe equipment have the same characteristics as daylight and react the same as the sun does with infrared film. Incandescent illumination has a much lower color temperature and is more amber in color than daylight or flash.

When dealing with dark indoor settings, the photographer needs to drag the shutter (have a long enough exposure) to pick up the illumination in the room. Remember that lamps, windows and other light sources will luminesce as the shutter speed is increased. This "glowing" effect can be very artistic and beautiful when handled properly — but it can also overwhelm the scene if it becomes too predominant in the image.

Mamiya 55mm wide angle lens.

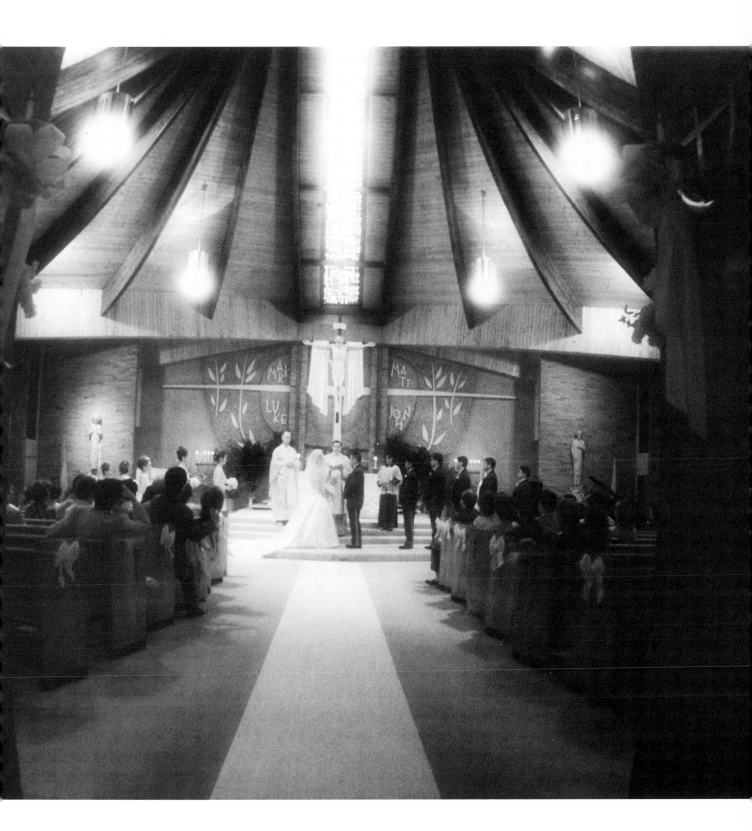

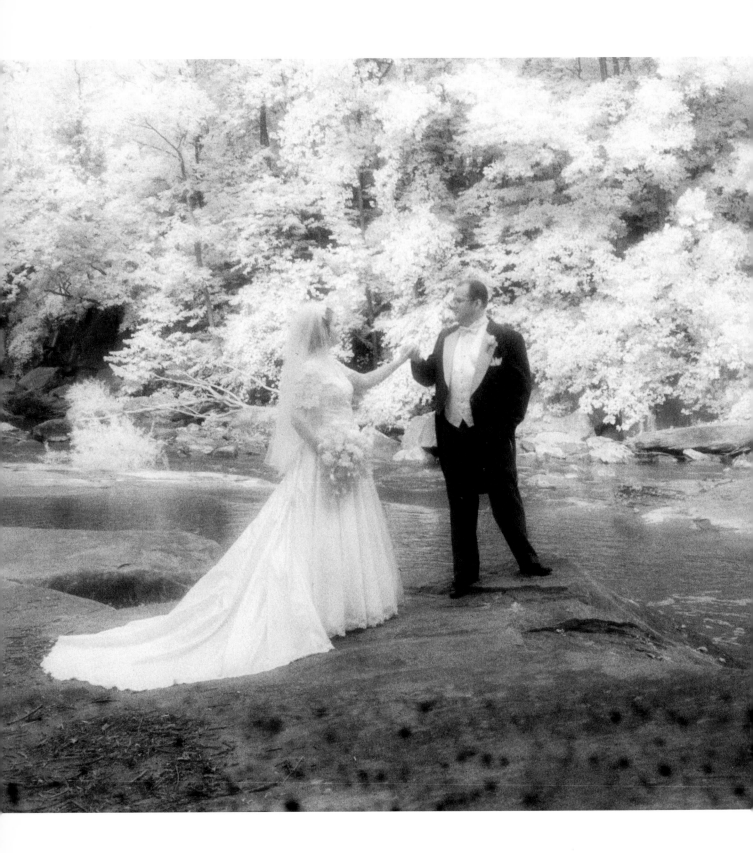

Technical Specifications

Travis created this photograph on the wedding day after the ceremony and prior to the reception. He used a Minolta 35mm camera with a 28mm lens. The lens had a number 25 red filter on the front of it. The Kodak infrared film was exposed at $f11$ at $1/60$ in the late afternoon.

The Setting

Travis was creating an image from a bridal magazine dress advertisement. This image has the groom gallantly holding the bride's hand as they look at each other. This was meant to be a casual yet classic wedding day image. The couple was in Olmsted Falls Park on Cleveland's West Side. The sun was popping in and out from behind the clouds.

Composition

Travis placed the bride and groom in the center of the frame and simply have the couple looking at each other. The groom's hand is in his pocket to add to the casual feel of an otherwise formal image.

Posing

We try to do what we call flow posing — one pose leads directly to the next with very little readjust-

ment of the subjects. Using of bridal magazine images helps the couple visualize the final shot and get into the right pose without a lot of tugging and pulling.

Adjusting the dress is easy with most gowns — you simply grab the end of the train at two places equidistant from the center seam and gently lift it up so that some air gathers under the material and the dress will blossom out perfectly and symmetrically.

Promoting Your Studio

We promote our photography studio in many ways. First, the majority of our business comes from customer referrals. We also get referrals from caterers, florists, disk jockies, bands, dress shops and other wedding vendors. In addition, several area photographers refer our services when they are not available to photograph a couple's wedding.

We also advertise in local bridal magazines and at bridal shows. We have printed handout materials (see below) that display our photographs in both infrared and regular black & white. This gives the couple something to take home with them after they have come to visit our studio. They are also great materials to mail out to clients seeking more information about our services.

Here's an example of our advertising handout. The original size is 11 x 8½.

Rice Photography
440.979.0770
Black & White Infrared
Photography Specialists
to add a "Dream Like" quality
to your wedding images.

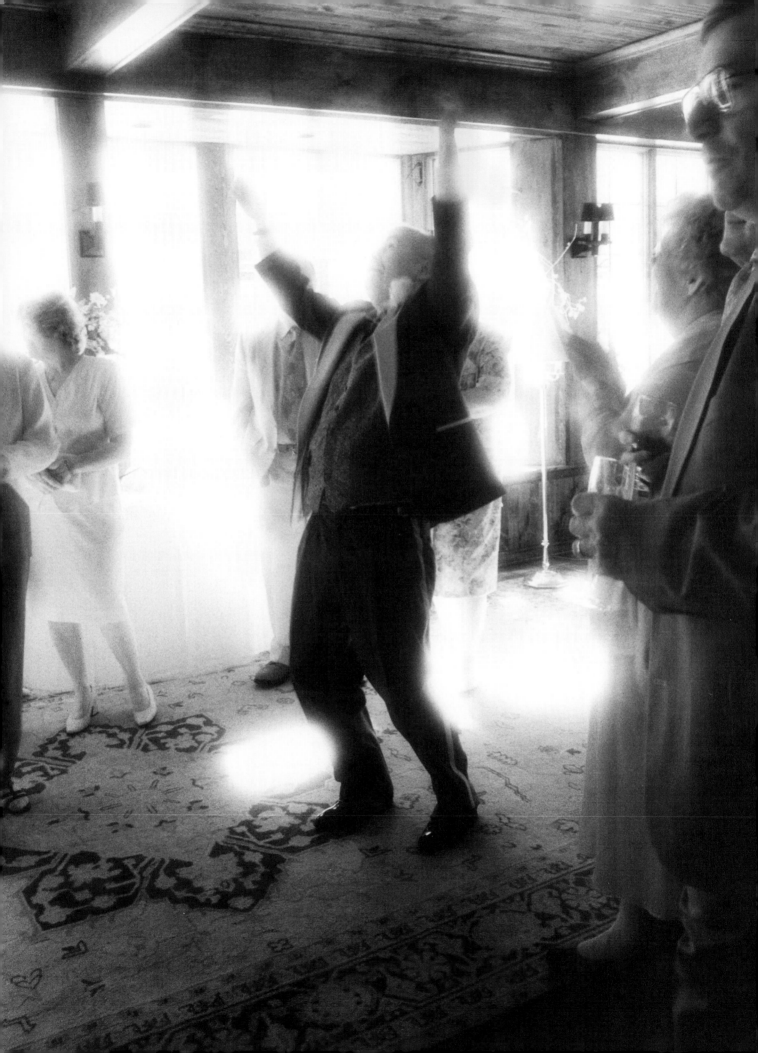

Technical Specifications

Barbara took this photograph at the bride and groom's wedding reception. She was using a Canon 35mm camera with a 28mm wide angle lens. There was a number 25 red filter in front of the lens. Barbara exposed Kodak infrared film at $f8$ at 1/30

The Setting

Barbara was looking to capture the feeling and emotion of the wedding reception. This was an afternoon reception and the main subject in the image is the groom dancing. With the bright afternoon sun, the light from the outside windows poured into the image and glowed, causing a nice contrast to the much darker subjects inside.

Composition

Barbara shot this as a pure candid image — very photojournalistic in nature. Nothing was planned or set up. As the groom became more animated, Barbara picked up her camera and fired off a quick shot in infrared. Since her purpose was to keep him in the frame, she centered the image so that he wouldn't leave the composition.

Lighting

Barbara used the strong light source from the window to balance the much darker subjects inside the reception hall. The halation adds to the interesting qualities of the final print.

The biggest precaution with shooting infrared indoors with strong outside light sources like these windows is to not allow the illumination to overwhelm the scene. This is a fine line and is best handled with some bracketing of the exposure — especially if you think there is a potential problem with the light. Just like with shooting infrared outdoors, it is better to bracket and use a couple of extra frames of film than to miss the chance to get a great photograph.

Candid Photos

The key with candid infrared photographs is to have your equipment ready and capture the moment as it unfolds in front of you. The photographer does not have time to focus and refocus the lens — you will miss the action.

We will zone focus the image by setting the lens on the distance we want to be from the subject and allowing the depth of field of the smaller aperture guarantee a sharp image. In this manner, we simply compose and shoot. Candids happen too quickly. You don't want to have to think about what you are doing. The photographer needs to see the action and take the picture.

With candid photography, it is better to stay further away from the subject and allow the events to unfold before your camera. If you are too close, you may distract the subjects and lose the realism in the photographs. The photos will look posed and not candid. We tend to use wide angle lenses for our candid photography to record as much of the scene and subjects as possible. In this way, the viewer gets an overview of what is going on.

IMAGE 45

Technical Specifications

Barbara took this image of the bride and groom on their wedding day after the ceremony and prior to the reception. She used a Canon 35mm camera with a 28mm wide angle lens. The lens had a number 25 red filter attached to the front of it. Barbara exposed the Kodak infrared film at $f8$ at 1.60.

The Setting

This photograph of the bride and groom was taken on the grounds of the Cleveland Museum of Art. The couple was placed in the shade of this willow tree in mid-afternoon. The bright light on the tree illuminates the foliage nicely in contrast to the dark grass that remained in the shade.

Composition

We photograph at the Cleveland Museum of Art quite often. Knowing from experience that the willow trees will look stunning in infrared, we always try to incorporate them into some of the images. By placing the couple in the shade, the scene takes on a different look than if they were placed directly in the sun. The much darker features stand out against the lightness of the trees. This photograph was taken in the late afternoon as the sun was beginning to set. The shadows were becoming more defined and the lake was nearly all in shadow, making the water appear near black in most places.

Water & Infrared

Water is rendered very contrasty with black & white infrared film. When the water is illuminated directly by the sun, it will record almost absolute white. When the water is in the shade, it will render nearly black. The effect is very dramatic and striking because it is unexpected. The lighting naturally plays a huge role as to how water will be recorded on infrared film. On a sunny day, the ratio between the brightest highlights and deepest shadows is very high. On a cloudy day, the ratio is much lower and the contrast is not as extreme.

Proofs

We do paper proof all of our wedding images — including our infrared photographs. We allow the bride and groom to take the proofs home to make the selections. We do this because we want the couples to show as many people as possible our creative work and increase the potential for extra orders by friends and relatives. If we made the couple choose their images in the studio, nobody else would get to see our wonderful photographs. Many of our bookings come as a direct result of a friend or relative seeing another couple's wedding proofs — not just their finished wedding album. Proof books are very portable and the bride can easily take them to work to show her friends.

Unfortunately, the possibility of some people copying photographs illegally will always exist. We do our best to educate both the client and the establishments that have the capability of copying a photograph that only the photographer has the right to create duplicates of an image they create. We gently impress upon them that it is illegal to make unauthorized reproductions.

Our wedding photography contract states that we retain the copyright for all photographs that we create. We also include a card in the proof book that tells the client that we retain the copyright of the images. All of our wedding proofs have the copyright symbol, the year, and "RICE PHOTOGRAPHY" imprinted on the back. Most retailers will not copy an image that has a photographer's copyright clearly marked on the back.

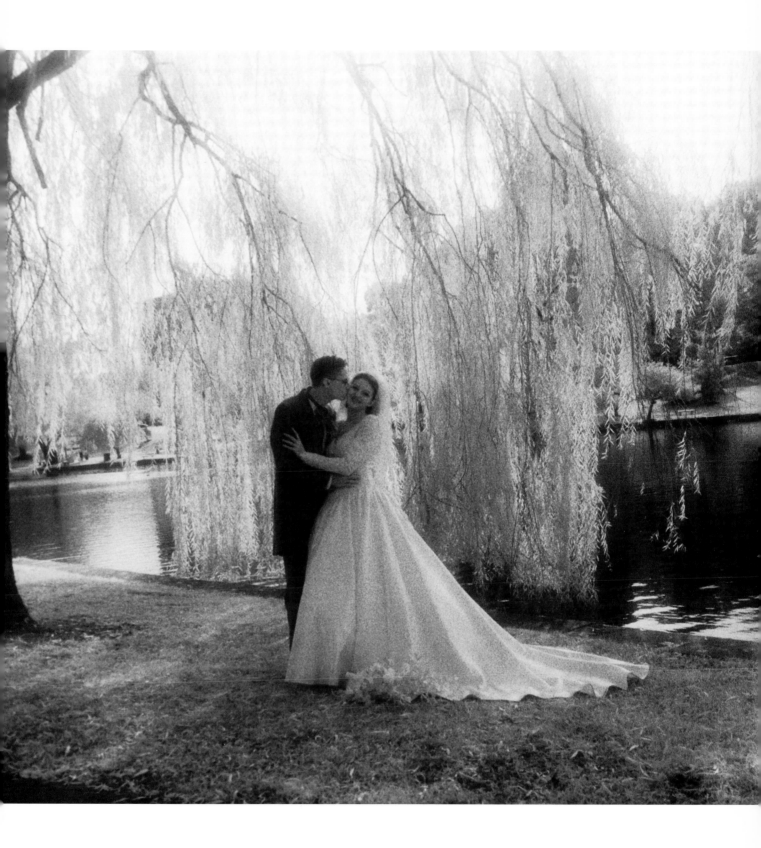

IMAGE 46

Technical Specifications

One of our associate photographers, Anthony Zimcosky, created this photograph of the bride and Groom on their wedding day. Anthony used a Minolta 35mm camera with a 28mm wide angle lens. The lens had a number 25 red filter attached to the front of it. Anthony exposed Kodak infrared film at ƒ11 at 1/250 on a bright sunny afternoon.

The Setting

Anthony created this photograph of the bride and groom at a park close to the site of their wedding reception. The image was taken after the wedding ceremony and prior to the start of the reception. It was mid-afternoon and the shadows were becoming more defined. Anthony chose to position the bride and groom so they were nearly backlit in the image. This is a very symmetrical image with the couple placed in the center of the frame looking back toward the camera.

The bride and groom had picked out this park location for their environmental images on their wedding day. The split rail fence rendered very dark against the lightness of the grass in the background. The scene was very simple and images were taken in both color and infrared. The infrared images were much more striking and the couple really enjoyed them. This photograph was taken in mid-afternoon as the shadows were beginning to get longer and more defined.

Lighting

The grass is nearly white because it is being richly illuminated by direct sunlight. The sky, too, is very light because Anthony is shooting nearly towards the sun and allowing the color to wash out in the image.

By placing the couple directly in the sunlight, you can be sure to get a usable infrared image. The shadows are dark and very deep and the shaded areas of the foliage also remain dark in the final print.

Infrared Orders

Our Brides and Grooms appreciate the use of infrared film on their wedding day and they certainly include it in their albums and as their wall portraits. It has become more and more common for parents to include infrared images in their albums as well. It is important that the parents understand why the film records the way it does for them to fully appreciate the infrared film. We try to explain completely why we use infrared film and the types of results you can expect.

Prior to the wedding day, it is important to present infrared film as an artistic film that gives a different, yet beautiful, rendering of the Bride and groom. If the couple understands what the film does, they can explain it to their families and friends. Many of the couples' friends order infrared images because they find them unique and interesting.

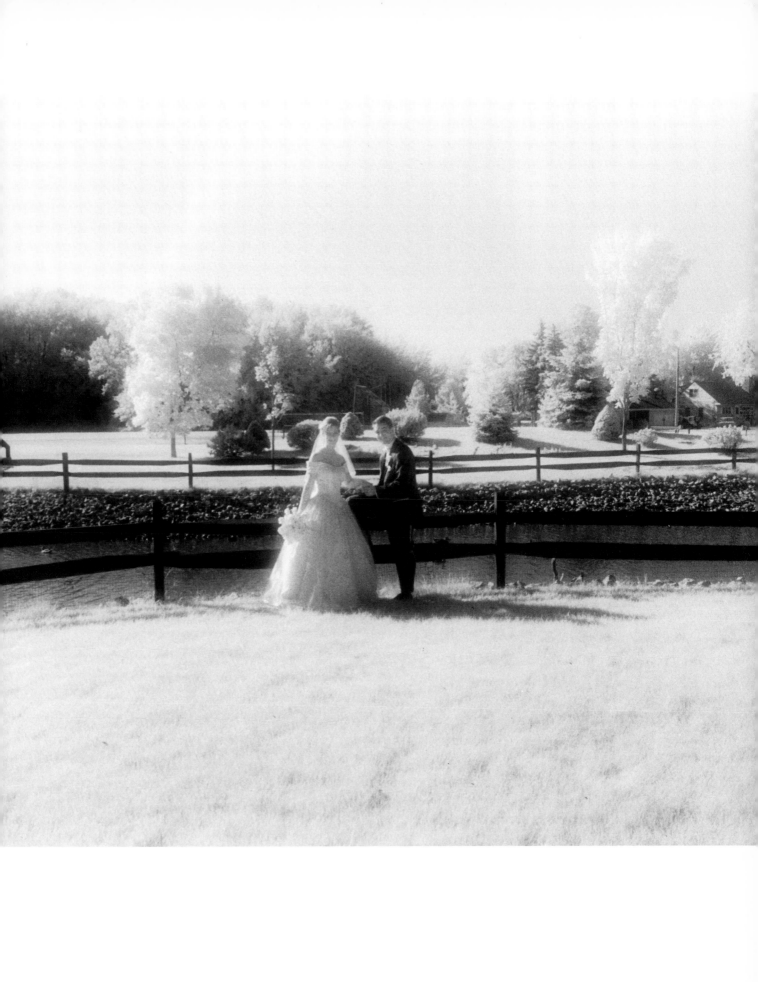

IMAGE 47

Technical Specifications

Travis took this photograph of the groom and flower girl on the wedding day. He used a Canon 35mm camera with a 16mm fisheye lens. The fisheye lens had a rear element number 25 red filter. Travis exposed the Kodak infrared film at $f11$ at 1/60 under light cloud cover. This image was cropped in for the final print.

The Setting

Travis took this candid image of the groom talking to the flower girl as they were both watching Barbara take photographs of the bride.

As a wedding photojournalist, Travis moves about and shoots moments like these. The people in the image were completely unaware that he was taking their photograph.

Travis truly captured a priceless moment with the groom and the flower girl. Images like this can't be posed or staged — they simply happen. Travis saw this moment unfold and created a photograph that will be treasured forever. The inclusion of the two brides-maids in the background added nice depth to the photograph and shooting on a diagonal to the subjects made the composition more interesting.

Cropping

We try to crop as much as possible through the lens in most situations. The reasons are simple. If we crop the image ideally in the camera, the clients know exactly what to expect in their final prints. Second, it is less expensive for us to use the lab standard "A" mask for 35mm negatives, than having a custom print made by ourselves or a commercial lab.

Depth of Field

Depth of field is the area of acceptable focus in a photograph. The actual point at which the lens is focused is the true focus point, however the lens opening will determine how much of the image will be acceptably in focus (still look sharp). As you stop down the lens, you will increase the depth of field in the photograph with any film. As you use wide angle lenses, you will give the feeling of increased depth of field because the subject appears to be further from the lens than with a normal or telephoto lens.

The importance of depth of field with infrared film is that it can eliminate the need for re-adjusting the focus to the infrared mark on the lens. The usable depth of field with smaller lens openings will "cover" the range between the actual focus point and the infrared readjustment mark.

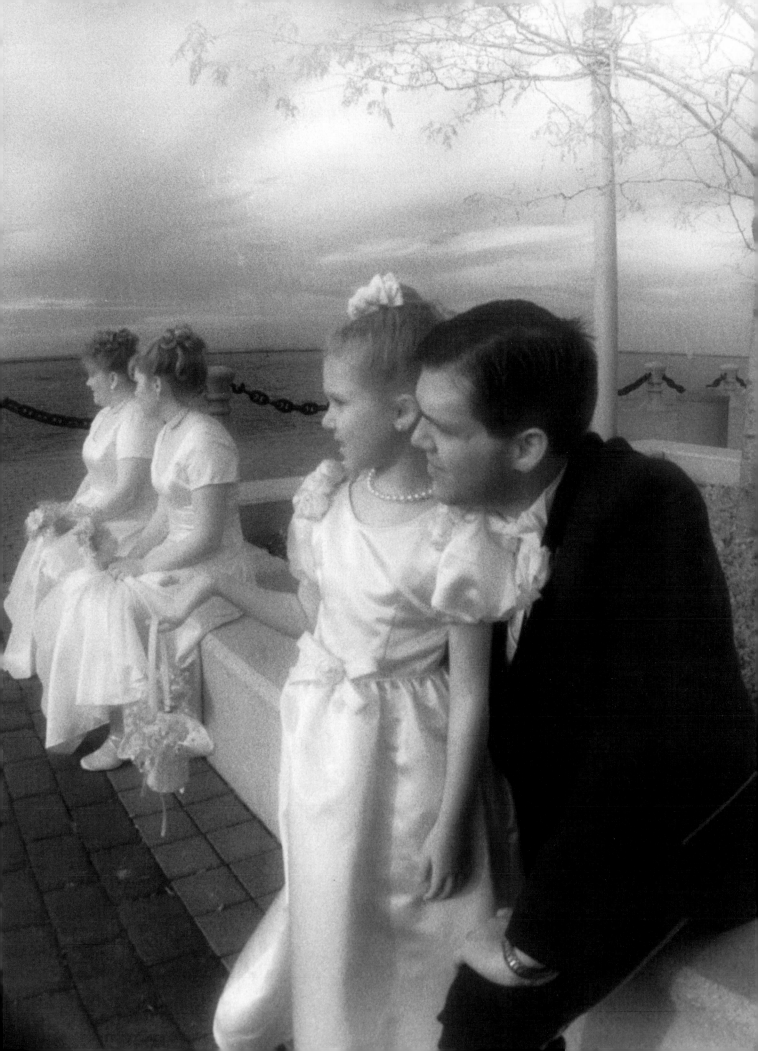

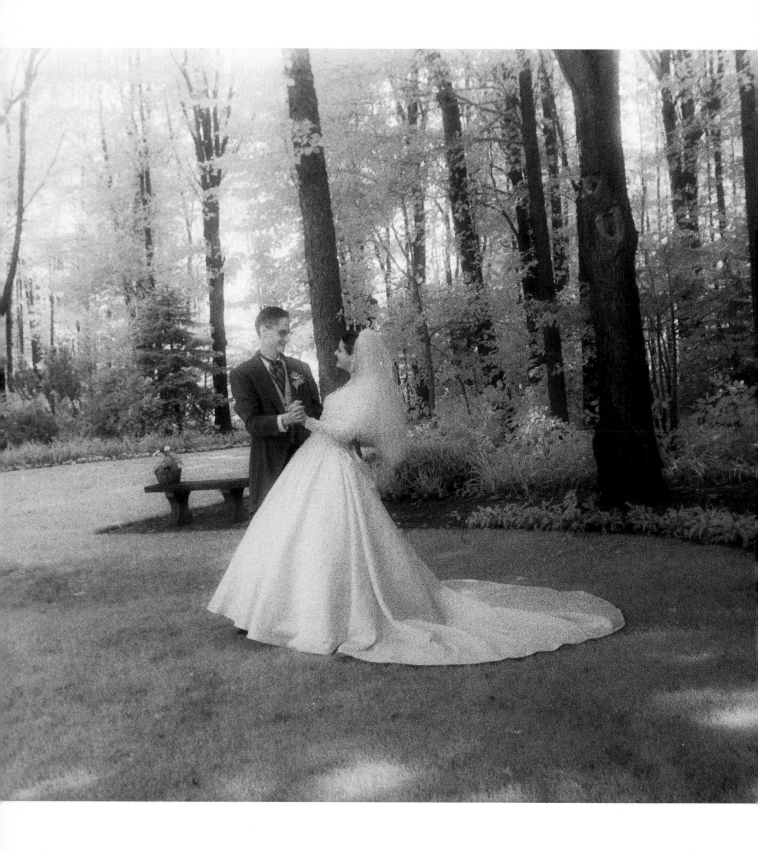

Technical Specifications

Barbara used a Pentex 35mm camera with a 28mm wide angle lens. The lens had a number 25 red filter attached to the front of it. Barbara exposed the Kodak infrared film at f8 at 1/60 with the couple in the shade.

The Setting

Barbara took this image of the bride and groom on their wedding day after the ceremony and prior to the reception outside the home of the bride's parents. She was looking to create a "dancing" pose of the bride and groom in this backyard park setting. She was concentrating on the expressions between the bride and groom and the feeling you get when viewing the image. It has a very candid feel to it for a posed photograph.

Composition

Barbara's composition of this image was fairly straightforward with the couple placed in the center of the image. The trees in the background are nicely sunlit and glow in the photograph, whereas the areas in shade are much more subdued. This photograph was similar to a bridal magazine dress advertisement where the groom was "dipping" the bride while they danced together.

Posing

We like images where the couple is looking at each other because they look real and not so posed. Our photographs look believable and fun, not stiff or contrived. When a couple looks at each other, we don't have to ask them to smile. They smile naturally and their expressions are something we can't elicit in the same way by asking them to look back at a camera.

We refer to our wedding style as relaxed, candid-looking wedding imaging. We strive for realism in our photographs and the expressions. We place couples in situations and record their reactions. It makes our imaging unique among photographers in our area.

Posing is accomplished in many ways. The experience that Barbara, Patrick and even Travis have gained over years of working with wedding couples has taught us how to place brides and grooms in an image for pleasing, interesting and exciting results.

In recent years, we have asked brides to pick out images from bridal magazine advertisements and show us the kinds of poses that interest them. We often use these advertisements to help the couple recreate the poses they desire. That was the case with this particular photograph.

IMAGE 49

Technical Specifications

Patrick took this image of the bride and groom on their wedding day after their ceremony and prior to the start of the reception. He used a Mamiya 645 Pro TL camera with a 35mm back and a 80mm lens. The lens had a number 25 red filter attached to the front of it. Patrick exposed Kodak infrared film at $f8$ at 1/60.

The Setting

Patrick had just finished taking all of the photographs of the bride and groom at Olmsted falls Community Park and instructed them to walk back to the bridge while he stayed at the edge of the river down below. Patrick gave the couple a copy of our infrared handout card that featured this pose and asked them to recreate the pose on the bridge. Using the handout piece saved him from having to go all the way back to the bridge to pose them or trying to shout posing instructions from 100 yards away. It worked very well and the couple was very pleased with the final infrared print.

Composition

In many of our photographs, we look at what would make a great scenic or environmental image if there were not any people in it. When you study a scene in this manner, you will create the most pleasing photograph at the location. After that is done, it is relatively easy to just add in your subjects, pose them and take a photograph. This would be a beautiful infrared image without any people in it. The couple is kept small with the use of a normal lens shot from a great distance away. The couple is an element in the composition, but not overpowering. It is more of an art print that happens to have a bride and groom in it. This technique is especially effective when creating an image that may become a wall print for the couple.

Foregrounds

Including foregrounds in an image adds depth to the photograph and gives the viewer the feeling of really looking into the scene. Foregrounds add dimension and make the image look less flat. When you are including foregrounds in an infrared photograph, you must decide if you want them to be in sharp focus or not. This will be determined by the aperture selected and the camera's distance to the nearest foreground area.

We sometimes make the foregrounds very sharp, but often we allow the photograph to gradually sharpen up as you look into the image. With infrared film, you need to be aware of the foreground and how it will render with the infrared film. A brightly illuminated plant or tree would have been distracting if it was included in the foreground of this image. We will sometimes move around or change focal length of the lens to give us choices in the final print if we are unsure how it will look.

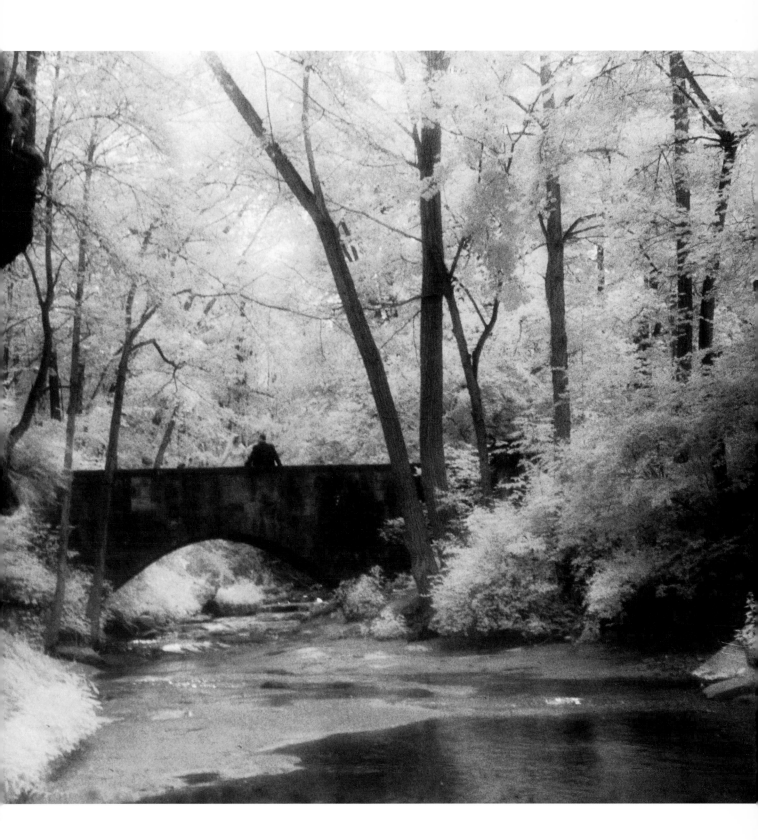

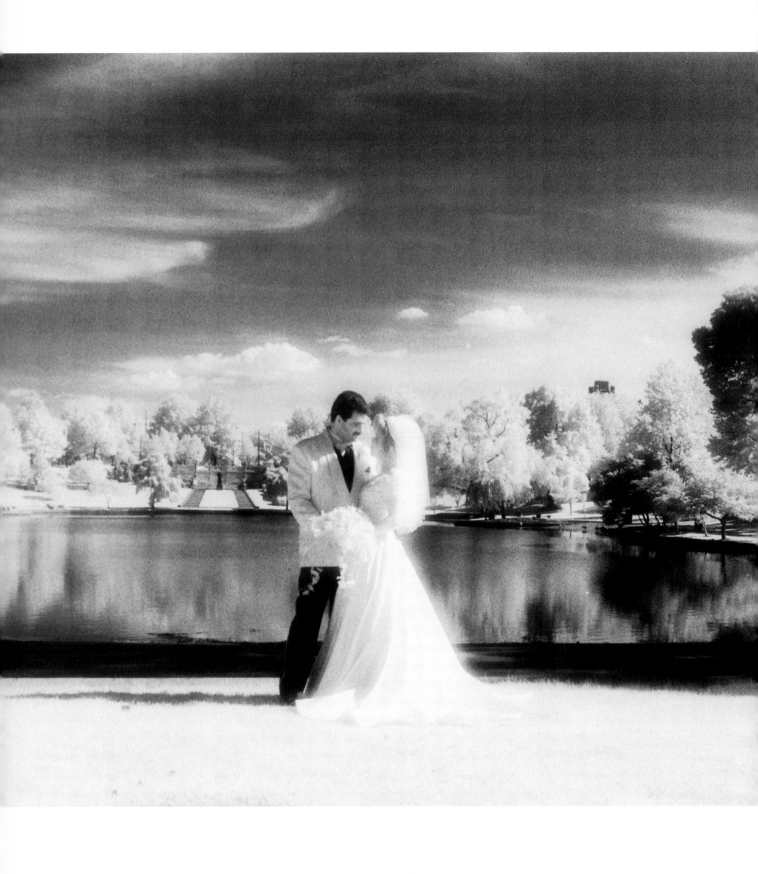

Technical Specifications

One of our associate photographers, Anthony Zimcosky, created this image of the bride and groom on the wedding day after their ceremony and prior to the start of the reception. Anthony used a Minolta 35mm camera with a 28mm wide angle lens. The lens had a number 25 red filter attached to the front of it. He exposed the Kodak infrared film at $f11$ at $1/250$ in the afternoon sun.

The Setting

Anthony took this photograph on the grounds of the Cleveland Museum of Art. He placed the couple in the center of the frame in front of the lake and had them look into each other's eyes for a warm, romantic image. The afternoon sun radiated off the bride's wedding gown and produced a very distinct shadow from the couple.

As mentioned earlier, the grounds of the Cleveland Museum of Art are very beautiful and very popular with many of our brides and grooms. The lake photographs very well in color, regular black & white and infrared. Anthony knew that the trees would glow with the Infrared film in the bright sun. The lake adds depth to the image and the background is not obstructed by any distracting elements.

Lighting

The natural light from the sun brightly lit the trees in the background as well as the bride and groom. The bride's gown and veil glowed from the infrared radiation in the scene and the beautiful blue skies were rendered darker by the infrared film with the red filter. The photograph was taken at 4:00 in the afternoon as the sun was slowing sinking over the horizon to the West.

Infrared Differences

The foliage is certainly one of the differences. With the infrared film, the trees that are brightly illuminated glow to near white in the image. The sky is rendered darker with the infrared than it would normally be. The bride simply radiates in the sun far more with the infrared film than she would have with regular black & white.

Typical Wedding Coverage

On a typical wedding, we will shoot one roll of Kodak infrared film. Although there are 36 exposures on the role, with bracketing, we will deliver about 20 photographs of about 10 different poses. This depends on how many infrared photographs were taken indoors where bracketing is not always necessary to ensure a quality image. Our typical wedding coverage has over 200 images delivered to the bride and groom — most of them in color. With some of our couples, we will have a nearly 50/50 split between color and black & white images. Rarely is there more black & white than color. People are still getting used to the idea that an album of predominantly black & white photographs is acceptable — much like it was in the days before color photography.

Technical Specifications

Travis took this photograph as the couple was about to be showered with bubbles after the ceremony. He used a Minolta 35mm camera with a 28mm wide angle lens and a number 25 red filter attached to the front of it. It was exposed at $f11$ at $1/60$.

The Setting

While Patrick was shooting with color film, Travis shot from near the front of the limousine with infrared. The action simply unfolded before him as the couple walked towards the car and got in. There is always a semi-clear path to the car through the wedding guests. Travis took advantage of this and used a very low camera angle.

Must-Get Shots

We always review the bride and groom's photo checklist with them about two weeks prior to their wedding. In this way, we all gain a much clearer understanding of what they expect and how the day should be scheduled to make all of the photographs happen.

Usually, if we don't get a "must get" photograph, it was because of something outside of our control. If we run out of time at a particular location — be it the house, church, park or reception — we may not get every image the couple asked for. If at all possible, we will try to get the image at the next location or some other spot. If the reason was something outside of our control (a relative left before the family photo was taken, somebody wasn't ready in time, etc.) we always write down the reason on the photo checklist so that we can explain that to the couple after the wedding. The checklist does state that the list does not guarantee every image checked off or written down. In any case, it doesn't happen very often and even when it does, the couple understands why.

Photo Checklist

Bride's House
() Bride at Window
() Bride looking at flowers
() Bride's mother adjusting veil
() Father putting penny in shoe
() Maid of Honor putting garter on bride
() Bride with bridesmaids
() Bride with sisters and brothers
() Bride with pets
() Bride with flower girl and ring bearer

Church
() Groom nervously looking at watch
() Groom before ceremony
() Groom's parents going down aisle
() Bride's mother going down aisle
() Bridesmaids going down aisle (number___)
() Flower girl with ring bearer going down aisle
() Father and Bride going down aisle
() Altar photos from balcony
() Exchanging of rings

Church (continued)
() Lighting of marriage candle
() Clergyman blessing couple
() Bride and Groom coming through:
 () rice
 () birdseed
 () balloons
 () bells
 () bubbles

After Ceremony on Altar
() Bride & Groom together
() Bride & Groom with:
 () her parents
 () her family
 () his family
 () his parents
 () entire bridal party
 () his grandparents
 () her grandparents
 () other (_____)

Continued on next page.

IMAGE 52

Technical Specifications

Barbara took this image of the bride and groom outside of their reception hall on the day of their wedding. She used a Canon 35mm camera with a 28mm wide angle lens. The lens had a number 25 red filter attached to the front of it. She exposed the Kodak infrared film at f5.6 at 1/60. The photo was taken in the late afternoon.

The Setting

Barbara wanted to create a casual photograph of the bride and groom away from the hustle and bustle of their friends and family. This bench on the side of the building was just secluded enough to allow for this more intimate portrait. The bench was mostly in the shade, so Barbara opened up the lens and slowed down the shutter speed to properly expose the photograph.

Composition

Barbara shot this image on an angle to create a diagonal line with both the side of the building and the bench the couple was sitting on. The couple was in the shade because that is where the bench was — the left of the frame is still in the sun. We love the realism in this photograph — it looks anything but posed. The camera angle with respect to the building and bench added a nice diagonal line that provides depth and dimension to the photograph. The contrast from dark shadows to light areas is very striking.

Lighting

This image was taken in the late afternoon when the sunlight is very directional. A sliver of light was illuminating the left edge of the building as well as the couple sitting on the bench. The light provided enough infrared radiation to give a great exposure of the bride and groom.

Continued from page 93.

Photo Checklist

Park
() Close up of Bride & Groom
() Entire Bridal Party
() Bride alone
() Groom alone
() Bride & Groom with best man and
　　maid of honor
() Bride with bridesmaids
() Groom with ushers
() Bride with her parents
() Groom with his parents
() Bride and Groom with parents

Reception
() Best man making toast before dinner
() Couple kissing at head table

Reception (continued)
() Cake close up
() Bride & Groom cutting cake
() Bride& Groom feeding cake to each other
() Bride & Groom dancing
() Bride dancing with parents
() Bridal party dancing (number_____)
() Bouquet toss
() Groom removing garter
() Garter toss
() Bride & Groom with couple that caught
　　bouquet and garter
() Posed and candid shots of guests
() Bride & Groom leaving reception
() Bride's father showing empty pockets
() Photo of band or DJ

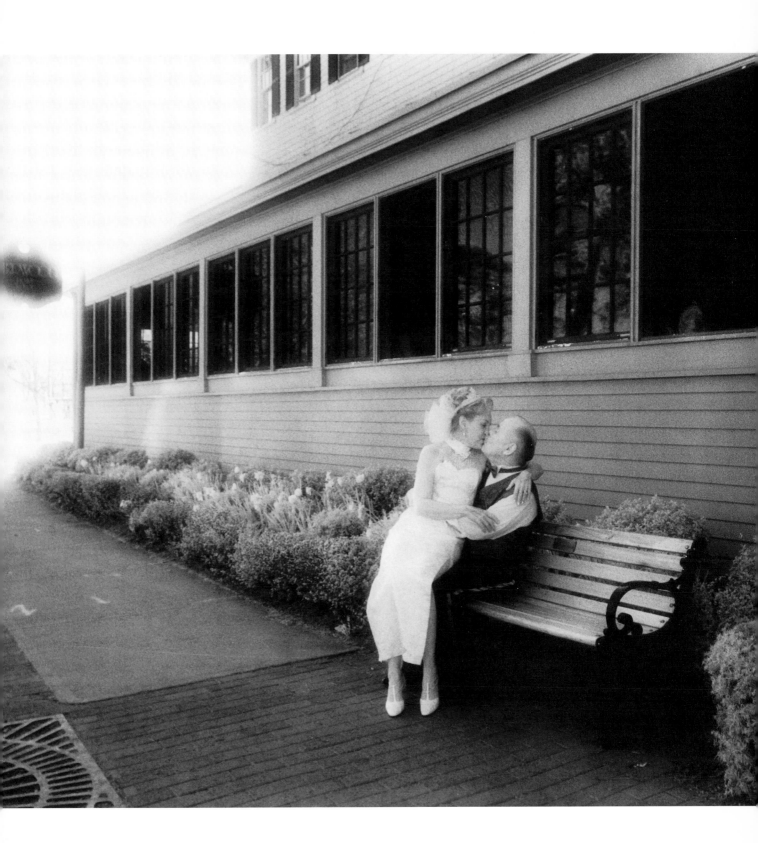

IMAGE 53

Technical Specifications

Patrick used a Minolta 35mm camera with a 28mm lens. The lens had a number 25 red filter attached to the front. He exposed the Kodak infrared film at *f*4 at 1/30. He hand-held the camera while standing next to the videographer. The light from his video camera helped to provide enough light to expose the photo.

The Setting

For this photograph, Patrick thought it would be interesting to get an image in infrared of the bride and groom dancing. We have taken infrared dancing photographs before, but have always used a flash on camera for illumination. For this image, Patrick didn't want to use a flash and have that kind of look in the photograph. He noticed the brightness of the videographer's light on top of his camera and felt that it would provide enough supplemental illumination to get an acceptable image. The lights in the reception hall were turned down for "mood lighting" and it was well past sunset so there was no illumination from outside windows.

Composition

The composition of this particular photograph was very straight-forward. Patrick moved in close to within about ten feet of the bride and groom and shot with a relatively slow shutter speed so that he could still hand-hold the camera.

The videographer was standing just to his side and helped illuminate the shot with his video light. Even though the lights in the reception hall were turned down, they still glowed with the infrared film.

Reception Photos

Whenever possible, we want to capture moments like this at the reception as they really happen. The expressions and emotions are real. The photos don't look posed.

We will sometimes ask people to dance together and then photograph the couple naturally (i.e. Ask the groom to dance with his grandmother, etc). We find that the suggestions we make will be very much appreciated long after the wedding when everyone sees the images.

When we get together with the couple a few of weeks before the wedding, we talk about the agenda for the reception. At that time, we discuss when the cake cutting will be, when the first dance will be, etc. Once we arrive at the reception, we go over the agenda with the musicians, band or DJ so that we all know the order of events for the evening.

Technical Specifications

Patrick used a Minolta 35mm camera with a 16mm fisheye lens. The lens had a built-in orange filter. He exposed Kodak infrared film at $f11$ at $1/125$.

The Setting

Patrick took this image of the bridesmaids entering the church just prior to the start of the wedding ceremony. Patrick was about 25 feet away from the subjects and used a fisheye lens to capture the entire scene. We are always looking to take interesting pho-

tographs of often overlooked parts of the wedding day. The bride and bridesmaids were driven from the hotel to the church in this trolley car. This journalistic image is artistically pleasing and helps tell the story of the wedding.

Consultation Session

Prior to any wedding we cover, we always have a consultation session with the couple. We go over the photo checklist (see pages 93 and 94) and also fill out an information sheet on the bride & groom and the wedding day details (see below and page 100).

Wedding Information Sheet

DATE OF WEDDING: _____

Bride's Name: _____ Groom's Name: _____

Address: _____ Address: _____

City: _____ City: _____

State: _____ Zip: _____ State: _____ Zip: _____

Home phone: _____ Home phone: _____

Work phone: _____ Work phone: _____

Email: _____ Email: _____

1st Location: _____ Time: _____

Address: _____

Directions _____

2nd Location: _____ Time: _____

Address: _____

Directions _____

3rd Location: _____ Time: _____

Address: _____

Directions _____

4th Location: _____ Time: _____

Address: _____

Directions _____

Bride dressing at: _____ phone: _____

Alternate location in case of rain: _____

Continued on next page.

IMAGE 55

Technical Specifications

Patrick used a Mamiya 645 Pro TL camera with a 35mm camera back and a 55mm wide angle lens. The lens had a number 25 red filter on the front of it. He exposed Kodak infrared film at $f11$ at 1/250.

The Setting

This couple had an afternoon reception at a beautiful country club on Cleveland's West Side. Patrick took the bride and groom out on the cart path along the 18th fairway for this image. Compositionally, he placed the bride and groom in the middle of the frame and had them relate to each other — be themselves and not think about having a picture taken.

Lighting

With the bright illumination from the sun, Patrick knew the grass would glow beautifully. The cart path was very dark and would create an interesting contrast to the brightly illuminated grass. The trees in the background lit up nicely. This was a good spot for an infrared photograph. The sun was starting to move across the sky in the afternoon before this couple's wedding reception. The bride was turned just enough for the sunlight to strike the front of her gown and glow in white. The trees that are being illuminated with direct sunlight will record white in infrared. Those trees that are in the shadows of the sun remain very dark in the image. This photograph was taken at 4:00 in the afternoon.

Continued from page 99.

Wedding Information Sheet

Maid of honor _____ Best Man _____

Additional # of bridesmaids _____ Additional # of groomsmen _____

Flower girl _____ age _____

Ring bearer _____ age _____

Bride's Family
Parents: _____

How many brothers: _____ How many are married: _____ w/children: _____

How many sisters: _____ How many are married: _____ w/children: _____

How many grandparents: _____

Groom's Family
Parents: _____

How many brothers: _____ How many are married: _____ w/children: _____

How many sisters: _____ How many are married: _____ w/children: _____

How many grandparents: _____

Full Mass or Communion: _____ Unity Candle: _____ Virgin Mary: _____

Receiving line @ church _____ @ reception _____

Bride being given away by: _____

Officiating Clergy Name: _____

Videophotographer (Co. Name): _____

Approximate # of people attending: _____ DJ ____ or Band _____

Bridal Dance: _____ Cake Cutting: _____ Bouquet and Garter: _____

Time Limo hired until _____ Cake cutting before dinner? ____ after dinner? ____

•Remind Bride to Bring Invitation•

Other Pertinent Information or Requests: _____

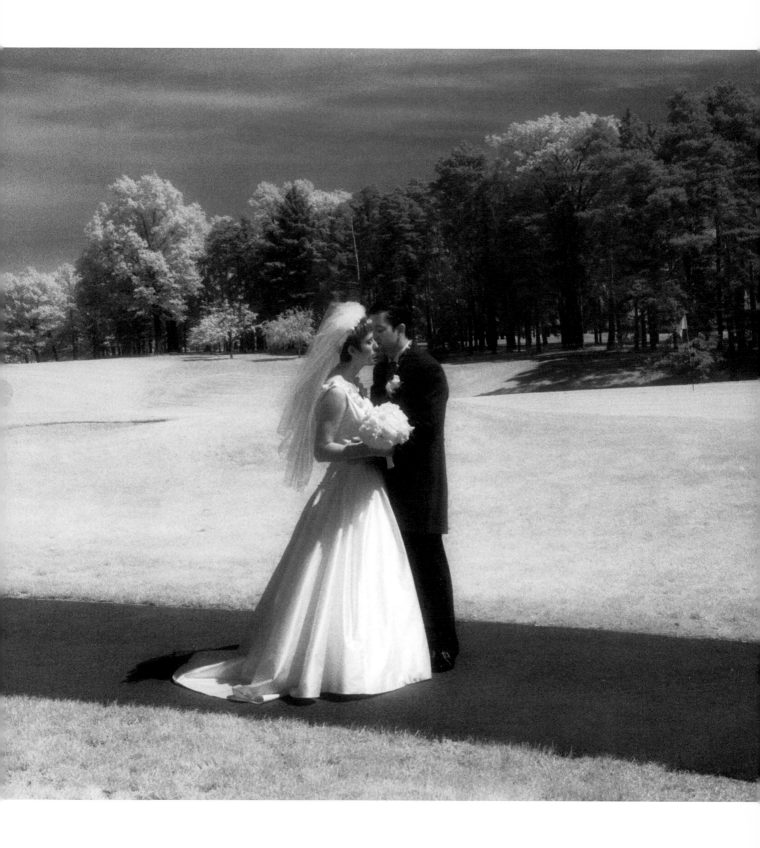

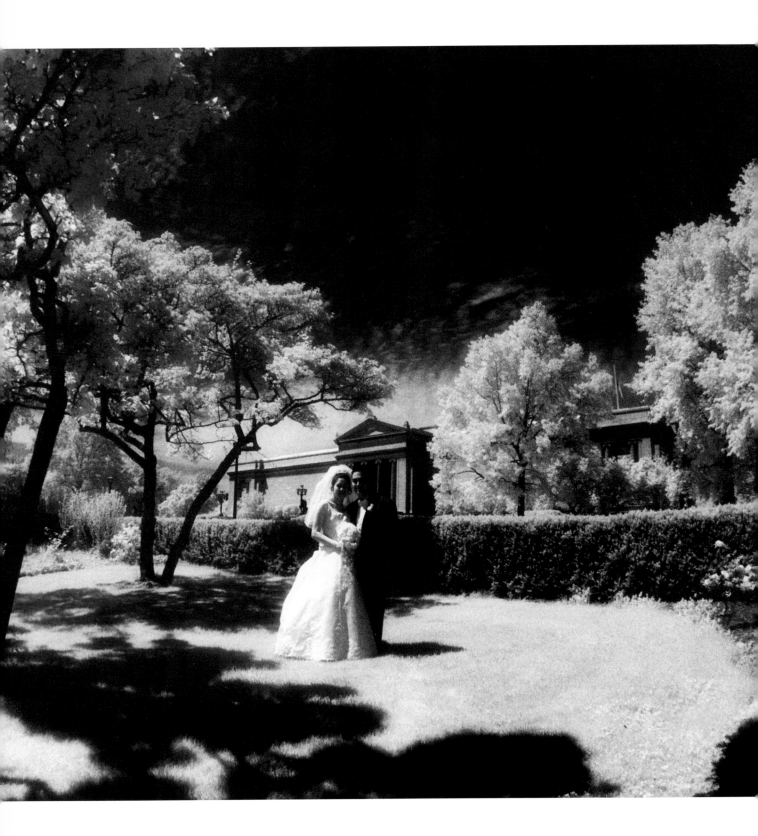

Technical Specifications

Patrick took this image of the bride and groom on their wedding day after the ceremony and prior to the reception. He used a Mamiya 645 Pro TL camera with a 35mm back and a 55mm wide angle lens. The lens had a number 25 red filter attached to the front of it. He exposed Kodak infrared film at f11 at 1/60.

The Setting

This photograph was taken on the grounds of the Cleveland Museum of Art. Patrick chose a centered composition of the couple in a very ordinary wedding pose with the couple looking back at the camera. After he took this photograph with color film, he thought it would be interesting to create the exact same image in infrared.

The entire area surrounding the Cleveland Museum of Art is very beautiful. Patrick chose this spot because the sunlight was illuminating a small area of the grass surrounded by the trees. Patrick didn't want the couple to be lost in the shadows, so he kept them just into the light and let them be cradled by the shadows. The shadows frame the bride and groom in the scene.

Infrared Differences

The deep, dark sky, the bright white of the tops of the trees, the white in the sunlit grass and especially the overall grain in the photograph are what sets the infrared apart.

Grain

When we discuss infrared photography with our clients, we show them a wide variety of infrared images. In some photographs, the couple is very clear, in others they are not. We point out that the infrared is somewhat unpredictable and the very grainy images have a "Monet-like" quality to them. We celebrate the artistic quality of these super grainy images.

If you want to have a less grainy look to your subjects, you must keep them in the sunlight and not in the shade or shadow areas. This couple's faces are mostly in the shadows. Infrared always looks sharper in the direct illumination of the sun or other infrared light source. If Patrick had turned the couple's faces toward the light, they would have been defined more clearly, but it also would have completely changed the look and feel of the final photograph.

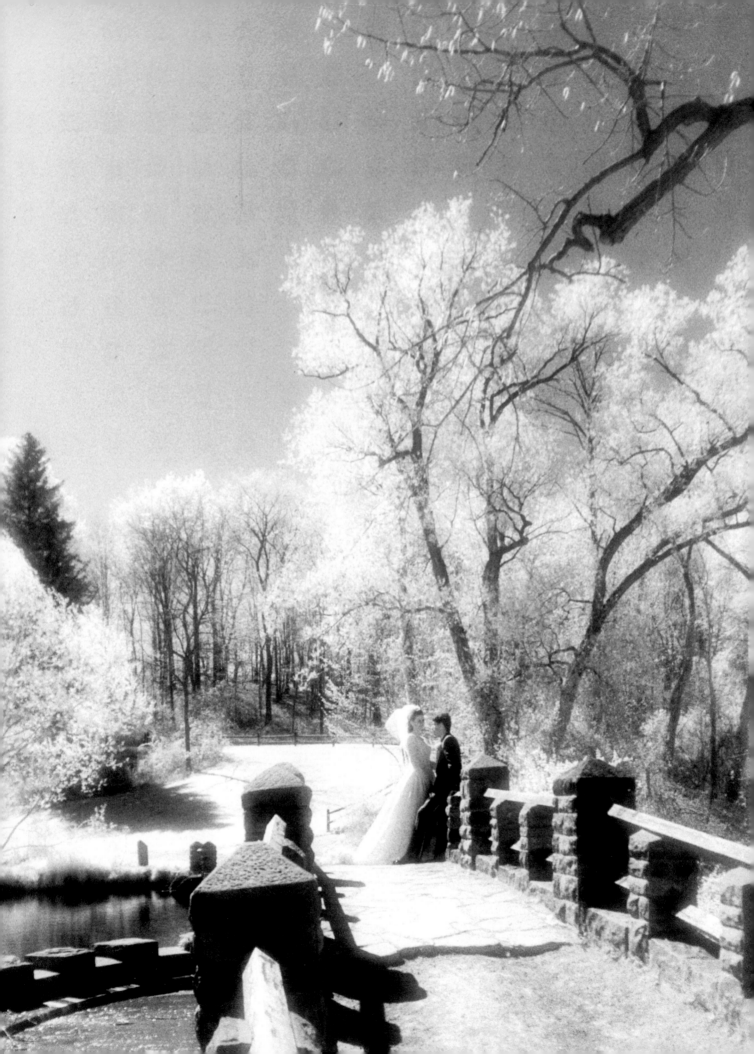

Technical Specifications

Patrick took this photograph of the bride and groom on their wedding day after their ceremony and prior to the reception. He used a Mamiya 645 Pro TL camera with a 35mm film back and a 55mm wide angle lens. The lens had a number 25 red filter on the front of it. He exposed the Kodak infrared film at $f11$ at 1/250 on a sunny afternoon.

The Setting

Patrick took this image in a park near the church where the bride and broom got married. This old stone foot bridge provided a wonderful setting for images of the couple. He chose to shoot diagonally from the couple – from the left corner of the bridge toward the bride and groom who were placed in the right corner opposite of him. The diagonal line from the bridge added depth to the photograph. Patrick placed the bride with her back to the sun so that her veil and dress would light up with the infrared film.

The scene was very tranquil and secluded. The background was completely enveloped in trees which Patrick knew would illuminate nicely with infrared film. The bridge had a classic and timeless quality. It was beautifully constructed nearly 75 years ago and is a popular spot for area residents to travel across.

Infrared Differences

The biggest difference with this image in infrared instead of "regular" black & white is the increased grain in the print, the sharp contrast between highlight and shadow areas, the beautiful luminescence of the foliage, and the glow of the bride's dress and veil.

Proof Schedule

We use a professional processing lab that is only an hour away from our studio — Buckeye Color Lab. Our film goes out to the lab on Monday following the weekend weddings, and we receive the proofs by the end of the week with the prints all numbered and the negatives cut and bagged. Our couples are usually still on their honeymoon when we receive their proofs and they pick them up sometime during the week they come back into town. Finished orders and wedding albums are generally ready within 6-8 weeks from the time the order is placed.

Images 58 and 59

Technical Specifications

Barbara took both of these photographs on a scheduled "reshoot" with the bride and groom several weeks after their wedding. These images were created as part of the *Photo Vision* video magazine series with Ed and Barbara Pierce. These images were featured on *Photo Vision*'s very first magazine video and this remains one the most popular excerpts. Barbara used a Canon EOS 1N 35mm camera with a 24mm wide angle lens. The lens had a number 25 red filter attached to the front of it. Barbara exposed the Kodak infrared film at $f11$ at 1/125.

The Setting

Both of these images were taken on the grounds of the Cleveland Museum of Art. In the top photo, Barbara placed the couple on the grass in front of the lake with the ducks entering the scene from the water's edge. The bottom image had the bride and groom to the right of the area in the top photo. The stone railing in front of the lake and under the willow tree provided a beautiful setting for an infrared photograph.

Differences Between the Photos

The images are different in appearance for a couple of reasons. The top photo was in an open area of the grounds of the Cleveland Museum of Art whereas the bottom photo was more hidden from the sun with the tree cover. In addition, there was light cloud cover and the sun was popping in and out between the clouds.

Scenes Made for Infrared

We look for a number of things in a scene to determine that it will be striking in infrared. Most important, we look for foliage that is being illuminated directly by the sun. We also enjoy utilizing stone walkways, railways and bridges to offer a stark contrast to the lightly rendered foliage.

For the most part, any sunny day can be photographed in infrared with interesting and pleasing results. Infrared film renders any scene in a way that can only be seen on the finished print to appreciate. When there is heavy cloud cover, infrared film is rendered very much like any "regular" black & white film.

Canon EOS IN

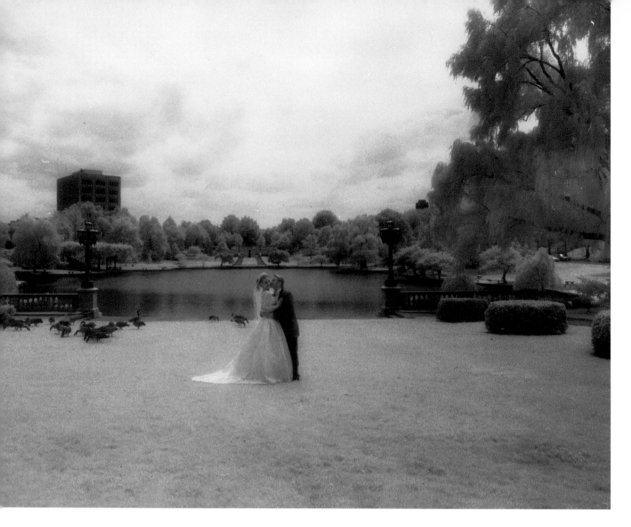

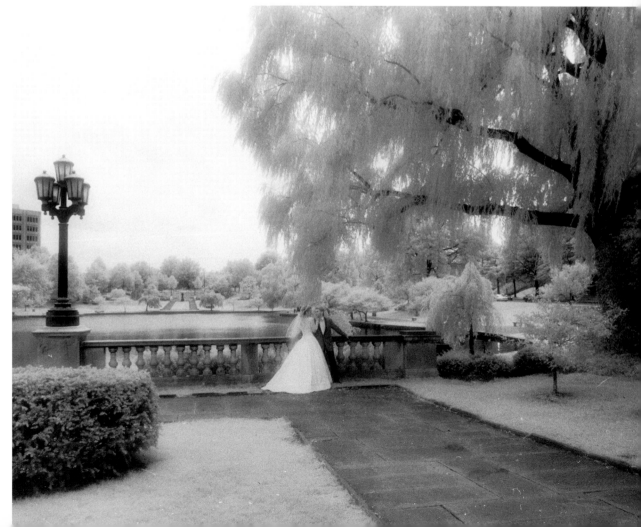

Image 60

Technical Specifications

Barbara took this photograph of the bride and groom on their wedding day after their ceremony and prior to their reception. She used a Canon 35mm camera with a 16mm fisheye lens. The lens had a rear element number 25 red filter attached to it. Barbara exposed Kodak infrared film at $f11$ at 1/250.

The Setting

Barbara created this photograph at a park near the church where the couple was married. She chose the fisheye lens to add some interest in the image with the distortion. Barbara tipped the camera down to include more of the foreground, bend the tree around the couple and bend the horizon line. The bride and groom were placed in the center of the frame so that they would not distort.

Lighting

This area of the park was richly illuminated by the afternoon sunlight. The large tree on the right provided wonderful "framing" for the couple — especially when enhanced with a fisheye lens.

Toning & Hand Coloring Photos

We both tint and hand color black & white photos — especially infrared. The art of hand coloring black & white photographs dates back to the mid 1800's, just after the advent of photography itself. Originally created to add color to a colorless medium, the process evolved over the years, but died out after the invention of color film.

Both photographers and the public lost interest in this artistic form and embraced the new color films. The hand colorists (then called hand tinting) were left out of photography in the early 1950's and most passed away without teaching their art form to a new generation.

Barbara is credited by many for bringing this lost art form back to the Greater Cleveland area and is considered the leading "artist" among area photographers. She has taught the hand coloring process to photography organizations across the country. In her 10 years of experience with hand coloring, Barbara has worked with all mediums of applying color to a black & white image. She prefers to use art pencils for small areas, and chalk or crayon pastels for larger areas. It is important that the image is printed on a flat matte paper when using these materials.

Barbara has also had success using the new Spot Pens Handcoloring Pen Sets. These apply to the paper easily and can be removed if you make a mistake. The Spot Pens can also be blended nicely for a smooth look to the colored area.

We do not present glossy-finish prints to our clients, and they do not work well for handcoloring. Only dyes and oils can be applied to a glossy surface.

Toning is achieved by sending the black & white negative to our commercial processing lab and asking them to print the photograph on color paper — not black & white paper. They can then select (dial in) a color that will be a continuos tone in the final print. We prefer brown toes and blue tones for most of our images.

We price hand coloring and toning very simply. We just double the price of a regular reprint in whatever size the couple wants. It doesn't matter how much or how little is colored. Some couples have large areas of the image colored, others choose to have just a subtle "hint" of coloring.

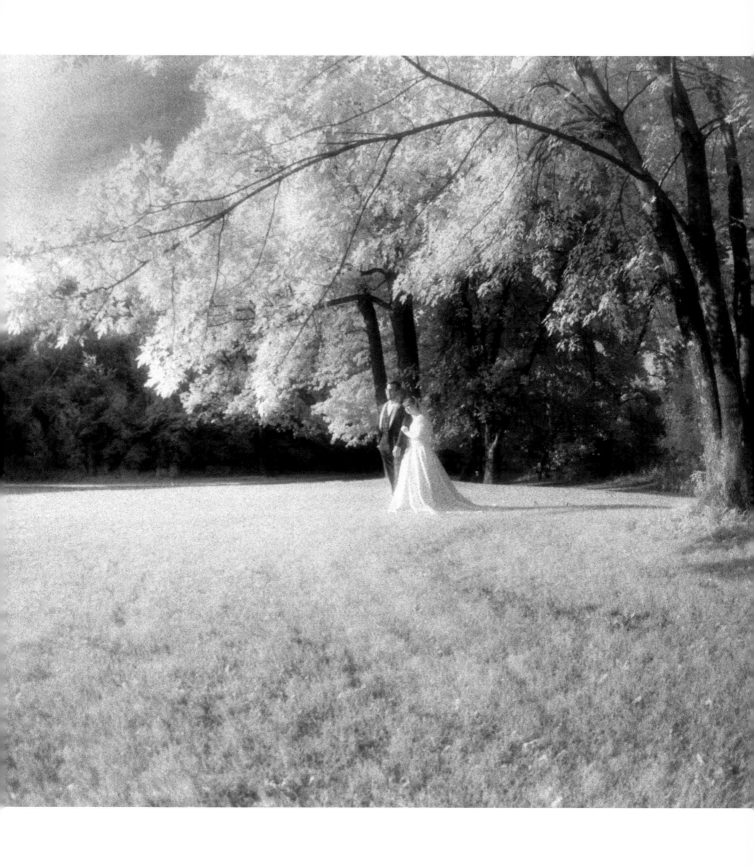

Technical Specifications

Patrick took this image at the couple's wedding reception. He used a Mamiya 645 Pro TL camera with a 35mm film back and a 45mm wide angle lens. The lens had a 77mm Tiffen number 25 red filter on the front of it. He exposed Kodak infrared film at $f8$ at 1/60 with a Metz flash unit.

The Setting

At this wedding, the band leader asked all of the single men in attendance to come up and join the band in a song. Some of the guys were given musical instruments and they all had a great time singing. This was a great moment for candids.

Composition

This image unfolded before Patrick without any warning and he simply raised his camera to record the action. He switched film backs on the Mamiya camera to record this in infrared as well as color. He wanted to see both the band leader and the guys singing in the same shot. His angle to the side of the stage recorded everything he was looking for. Notice how one of the groomsmen's trousers recorded with the infrared — the black satin stripe glowed nearly white!

Covering Receptions

We try to photograph a wedding reception as candidly as possible. This is where our skill as wedding photojournalists really shines. At a wedding reception, you have to anticipate the action and be aware of everything going on around you. Special moments can create memorable images — if you get them on film.

Although it rarely happens, we have been at wedding receptions that have, at times, gotten out of hand. On a few occasions, guests, bridal party members, and even an a bride and groom have gotten into fist fights with people at the reception. When these events happen, we back off and stop taking images. These are not moments the couple wants to remember in photos.

We always stay at the reception at least as long as we must to make sure all of the important events have been recorded. Typically, we stay up to the final hour of the reception. The last hour is usually the point when everything starts to wind down and the guests begin leaving.

At the reception, we try to always keep a watchful eye on our equipment. No piece of equipment is left outside of a case. We also try to consolidate equipment by the time the reception begins. Much of our equipment has been returned to our vehicles and we only bring in the equipment we need.

We usually place our camera bags next to the band or DJ and ask them to keep an eye on it when we are taking photos.

Metz flash unit

IMAGE 62

Technical Specifications

Patrick took this photograph of the bride and groom after the ceremony on the grounds of the country club where the reception was later to be held. He used a Mamiya 645 Pro TL camera with a 35mm back and a 45mm wide angle lens. The lens had a 77mm number 25 red filter attached to the front of it. Patrick exposed Kodak infrared film at $f11$ at 1/250.

The Setting

This image was taken on the golf course cart path. Patrick likes the way that cart paths photograph in infrared (he has done this many times before) because of the stark contrast between the path and the richly sun-drenched grass. Patrick chose a simple centered composition with the couple relating to each other. He was looking for a more natural feel to the image.

The Background

It was mid-afternoon on a very bright sunny day. The background was enclosed nicely with these huge trees of differing heights. The trees gave a sculpted look that you don't always find in a park location. By this we mean that, usually, all the trees are the same height (probably because they are the same type of tree and were planted at the same time). In this setting, the trees are different types, different shapes and different heights. It makes the background far more interesting and it adds interest to the image. This was complemented by the blue sky that recorded very dark with the infrared. The bride's glowing white gown stood out nicely on the dark path — she would have nearly blended into the grass if posed on it. The groom was moved almost in front of the bride so that his tux would be against the white areas of the photo — the bride's dress and the light foliage.

Calming Influence

We believe that the best way to keep the couple calm on their wedding day is to properly prepare them *before* the wedding. We do this with our photo checklist and information sheets, with our "Tips to Make Your Day Go Smoother" sheet (see page 122) and by talking over the schedule of events with the couple. It can be a nerve-wracking day for the couple and many things are out of our control. We always ask if there is anything we can do to help. We will get the couple something to drink if they get stuck standing in the same spot for a long period of time (i.e. receiving line at reception). We also act as the messenger to communicate the couple's wishes to the band/DJ, caterer, etc. We even carry an emergency supply kit of safety pins, hair pins, Shout® wipes (for stains), boutenere pins, scissors, sewing kit, tape, hair spray, etc. to be able to help in any way possible.

The only time we have really seen couples upset with each other is after they smash cake all over each other. We try to discourage couples from doing this, of course. We don't want our couples mad at each other and we don't want them to have to spend a lot of time wiping off cake or reapplying make-up.

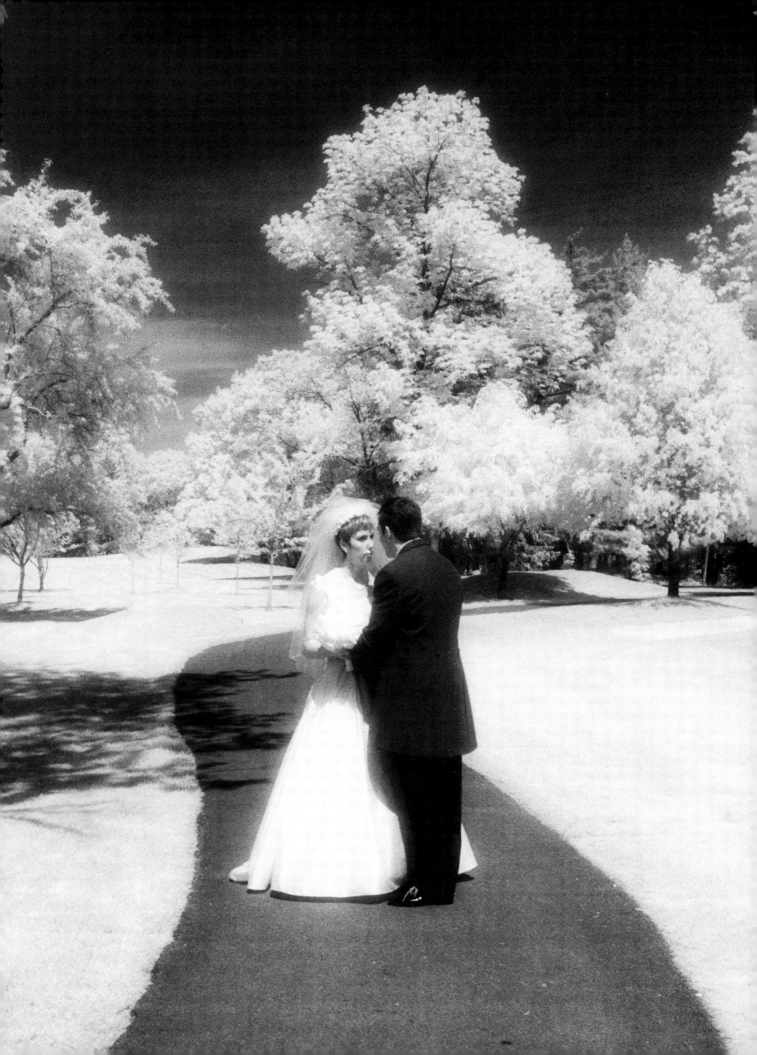

IMAGES 63 AND 64

Technical Specifications

Travis took both of these images of these brides and grooms at their weddings. His intention was to create images that Patrick wouldn't be getting at the front of each couple from outside the churches. Travis used a Minolta 35mm camera with a 28mm lens for the top image and a 40mm lens for the photo on the bottom. There was a number 25 red filter in front of each lens. He exposed the Kodak infrared film for both photographs at f11 at 1/125.

The Setting

For both images, the brides and grooms were about to exit the church to be welcomed by their guests with bubbles, bird seed, rice, etc. In the top photo, the couple was heading out the door as Travis took the photograph.

For the bottom image, Travis asked the couple to look at each other for a moment before they went outside. He created perfect silhouettes of the couple. Travis used a normal lens for this shot to create a closer and more intimate portrait of the bride and groom. Travis routinely takes images like these while Patrick is outside recording the action with color film. In this way, we give the couple two different views of the same moment and they usually put both into their finished album.

Composition

Photographing the bride and groom as they leave the church is a very common wedding image. Taking the pictures from behind the couple is an uncommon approach to a common idea. We are always looking for that unique way to record the scene and capture the moment.

Exposure is based on what we feel the exposure is outdoors. We want the couples to be silhouetted in these images. We love the dramatic contrast between the very dark main subjects and the very light secondary subjects (guests).

Silhouettes

These photographs are exactly like we planned them to look. Creating silhouettes in a doorway is a common photograph for us. We do it with all film types and in many locations. Travis specializes in infrared photography, so it was just a matter of applying the principles of creating silhouettes to the infrared.

To create these perfect silhouettes, you simply take a meter reading for the exposure outside of the building where the couple is standing. This will underexposed the image several stops and give the silhouette.

It is also important to choose your camera angle in such a way that you get a "clean" silhouette — by this we mean that you can easily distinguish the features of the main subjects.

For the image on the bottom, Travis had the couple touch the tops of their heads to add that special closeness to the image that is lacking in many wedding photographs.

IMAGE 65

Technical Specifications

Travis took this photograph of the bride and groom as they were about to enter their limousine after the wedding ceremony. He used a Canon 35mm camera with a 28mm wide angle lens. The lens had a number 25 red filter on the front of it. Travis exposed the Kodak infrared film at $f11$ at 1/50.

The Setting

Just as the bride and groom were entering the car, Travis asked the couple to look at each other and hold hands. The image still looks very candid, but the posing guidance to the couple made this a much better final image. Travis took an angle to the car to see the back of the vehicle and have a clear view of the bride and groom. This scene is a familiar event on the day of the wedding. Travis' image with the infrared film made this photograph more interesting and different than what we expect to see.

Inclement Weather

On a rainy day, it is necessary to open up the lens and shoot at slower shutter speeds for a proper exposure. Without the bright sunlight, the foliage will not be as white and the contrast from light to dark will not be as intense. We tell our couples that if it is overcast or raining, their infrared images will not have the same "punch" to them and will look more panchromatic (like regular black & white).

Snow, like most everything that is truly white, radiates and glows in infrared when it is illuminated by the sun.

The Growing Popularity of Infrared

Infrared is becoming more and more popular because it is different and intriguing. I believe the key here is this — with infrared film, some things in a scene record the way we would expect they should in black & white, while others are completely different. In other words — the film is illogical to the casual observer. People often refer to infrared as mysterious because they don't understand how it works and why it records the way it does.

We know of only a few photographers across the country that are using infrared film on weddings with any consistency. Many photographers have "tried" infrared film — some even on weddings — but very few offer the service or use the film in much of their work. I believe more and more photographers will begin using infrared film once they understand how to get good images and how to market it to their customers.

The biggest mistake most photographers make is insisting on processing the film themselves. The reason why this is a mistake has nothing to do with the processing of the film. It has everything to do with what you have to show the couple. Most photographers do not have the time or desire to personally make proofs from all of their negatives. The same is true of infrared. You can NOT sell infrared images from a contact sheet. The images are too small and they are not printed to their full potential. The secret is to find a commercial processing lab that will process and proof your infrared film at a reasonable price. We use Buckeye Color Lab in North Canton, Ohio. They do an excellent job, they are fast and they number all of the prints and negatives. This makes us more efficient and allows us to spend more time taking pictures and making sales — not making prints in the darkroom.

Years back, all studios made their own black & white prints — including proofs. However, today's wedding photographer shoots considerably more images on the wedding day than photographers used to, so there isn't enough time to make all of the proofs.

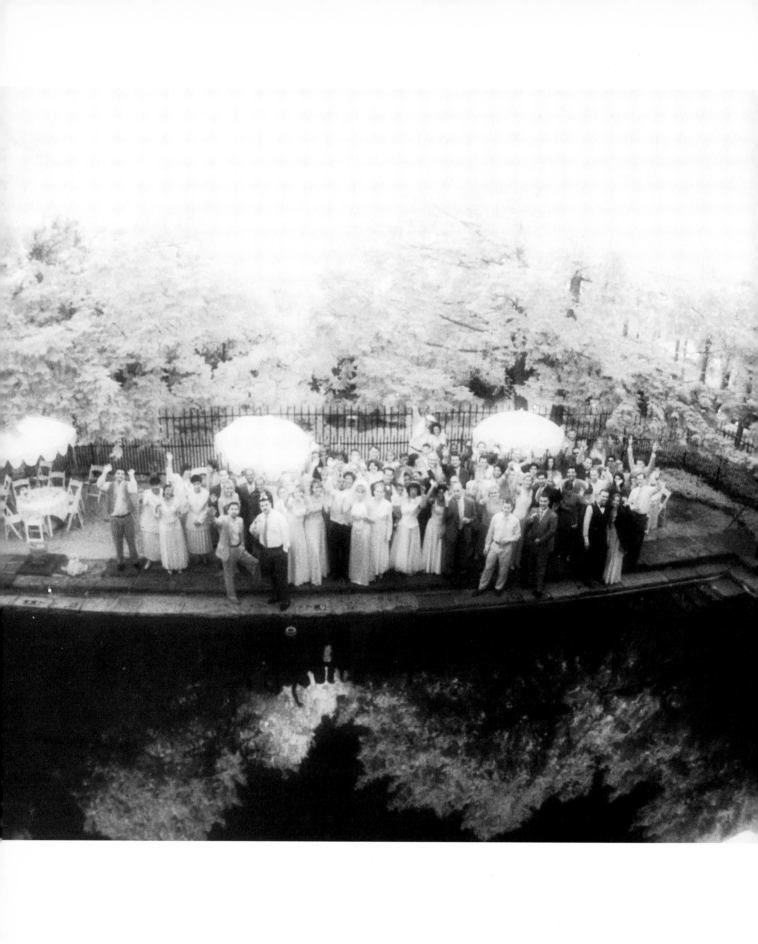

Technical Specifications

Barbara took this image of all of the wedding guests at the couple's wedding reception. Barb used a Canon 35mm camera with a 28mm wide angle lens. The lens had a number 25 red filter attached to the front of it. Barbara exposed Kodak infrared film at $f8$ at 1/60.

The Setting

Barbara took this image at an outdoor wedding reception from a second floor window of the adjacent building. She asked the bridal party to gather all of the guests in front of the pond and look back at her to create this fun image. Barbara wanted to include the foreground to add some interest to the image. Water that is not directly illuminated by the sun records very dark in infrared.

In order to see everyone in the shot, Barbara knew she had to take a high vantage point with her camera. The adjacent building to their outdoor reception was accessible and Barb scouted the area just after she arrived at the reception site. It is important to us and our clients to always be looking for intriguing ways to make wedding photographs. Very few couples are able to look back at an image that includes absolutely everyone that attended their wedding reception. This one can. Barbara took this photograph in both color and infrared. The couple used the infrared image in their finished album.

Differences in Infrared

With infrared film, the final print has more grain, the foliage glows nicely, the unlit water in the pond rendered nearly black and some of the women who wore red dresses are now in white dresses because of the film and red filter.

Help from the Bridal Party

Barbara took the approach of asking the bridal party members to gather all of the guests for this shot. This was helpful for a couple of reasons. First, there were several of them that could go around and "collect" the guests instead of Barb and her assistant trying to chase everyone down. Second, the guests know the bridal party members and are more willing to cooperate with them than with a photographer who is a stranger to them. We often enlist the assistance of bridal party and family members to gather people for our photographs.

Technical Specifications

Travis created this infrared image of the bride and groom on their wedding day after their ceremony and prior to the start of their reception. Travis used a Canon 35mm camera with a 16mm fisheye lens. The lens had a rear element screw on red filter attached to it. He exposed the Kodak infrared film at $f4$ at 1/4 with the camera on a tripod.

The Setting

With the fisheye lens in the vertical mode, Travis kept the bride and groom in the lower center of the composition and captured the exquisite ceilings of this magnificent building. The Palace Theatre is a popular indoor location for Cleveland area brides and grooms. The fisheye lens allows the photographer to record as much of the interior as possible. The infrared film gave the couple a different look in a familiar location.

When Travis assists on a wedding, he is typically shooting infrared and regular black & white while the principle photographer records the wedding in color. In this manner, the couple gets diversity in their images and the principle photographer (myself, Barbara or Anthony Zimcosky) can concentrate on other areas of the wedding coverage.

Using a Tripod

Travis used a tripod to create this infrared image. Whenever we want to pickup the detail in the background of a location, we always use a tripod. We use Bogen tripods for their strength, reliability and versatility. We personally like the model 3051 automatic tripod. With the model 3051, you push any two of the three red grips near the head and the legs collapse. Once you let go, the legs automatically lock wherever they are. This tripod is especially handy when the ground is uneven or you are standing on steps.

The only disadvantage to using a tripod is that it slows you down as a photographer. The advantages are many. First and foremost, you always have a steady camera support system to keep the images tack sharp and without camera movement. The tripod also allows you to get images that would not be possible by hand-holding the camera.

Manfrotto Automatic Tripod. Photo courtesy of Bogen.

IMAGE 68

Technical Specifications

Barbara took this image of the bride and groom on their wedding day after the ceremony and before the reception. She used a Canon 35mm camera with a 28mm wide angle lens. The lens had a number 25 red filter attached to the front of it. Barbara exposed the Kodak infrared film at $f11$ at 1/125 in the late afternoon sun.

The Setting

The idea Barbara was looking to communicate was a romantic image where the groom was about to present his new bride a red rose. The groom has his back to the camera so we are seeing the image from just behind him and sharing his point of view of the scene. The setting was a park nearby the reception hall.

Composition

Barbara posed the couple so that the viewer is looking over the groom's shoulder toward the bride. The red rose is rendered white with the infrared film and number 25 red filter. The tree overhanging the top right side of the image is nicely balanced by the openness on the left side of the frame.

Little Tips to Make Your Day Go Smoother

The following ideas are meant to help your day run more smoothly and prevent small catastrophes on your special day. In addition, these tips will help you to save time, fully enjoy your day and allow us time for your photographs.

- Put together a small "emergency kit" of safety pins, straight pins, needle and thread (white, black, and the colors of bridesmaids' and mothers' dresses), aspirin, Tylenol, Tums, Band-Aids, etc.

- In your car, limo or other vehicle, have coolers of your favorite beverages so that you don't have to stop at the local convenience store when people get thirsty.

- If members of your bridal party smoke, have a pack of their favorite cigarettes available in advance of the day and give it to them if/when they run out so you don't need to make a special stop to purchase more.

- Try to make sure everyone eats before the wedding. It is a long day and you and your bridal party will get hungry. Have food at the house for the bridesmaids to munch on before the service. Bring cookies, crackers, donuts (no jelly, cream filled or powdered sugar), fruit and anything else you might enjoy eating during the day.

- Lastly, plan with your wedding professionals the schedule of events for your day. Write down the times for the bridesmaids and ushers to arrive first, when everyone should be ready, when photos will begin, when you need to leave for the church (or other ceremony location), what time dinner will begin, when you will cut the cake, have your first dance, toss bouquet and garter, etc. Make copies of this list and give one to your photographer, florist, band/DJ, and also each member of your bridal party as well as the parents and other relatives. The more people understand the order of events on your day, the smoother the day will be!

This is an example of a "tip sheet" we give to the brides prior to their wedding day.

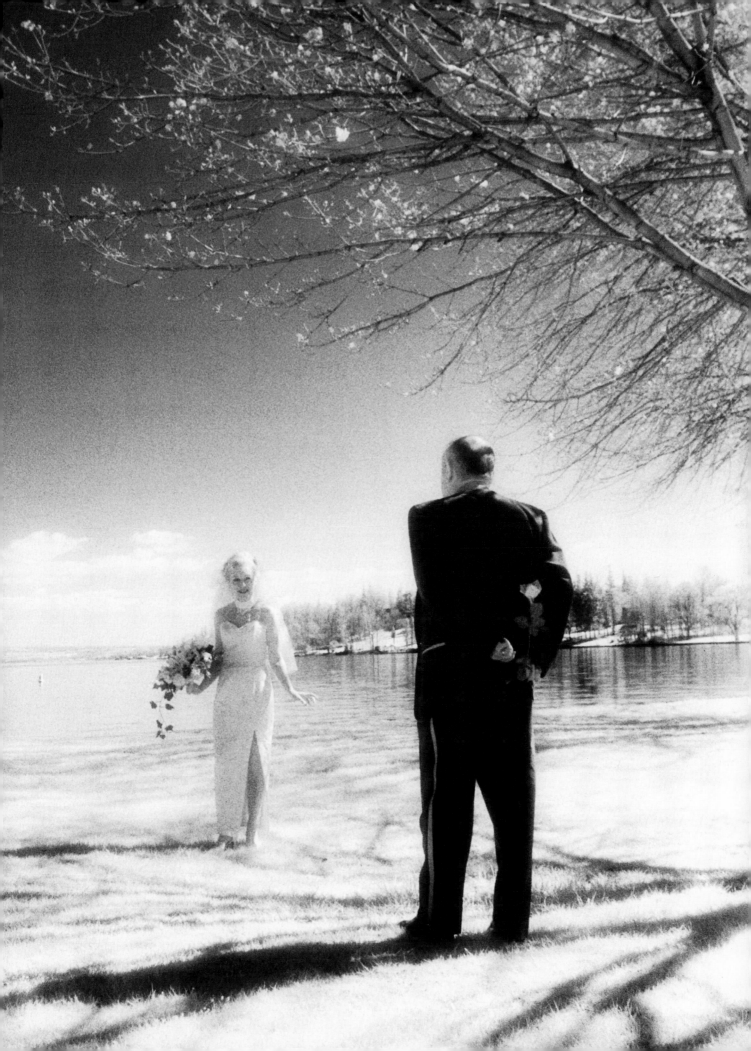

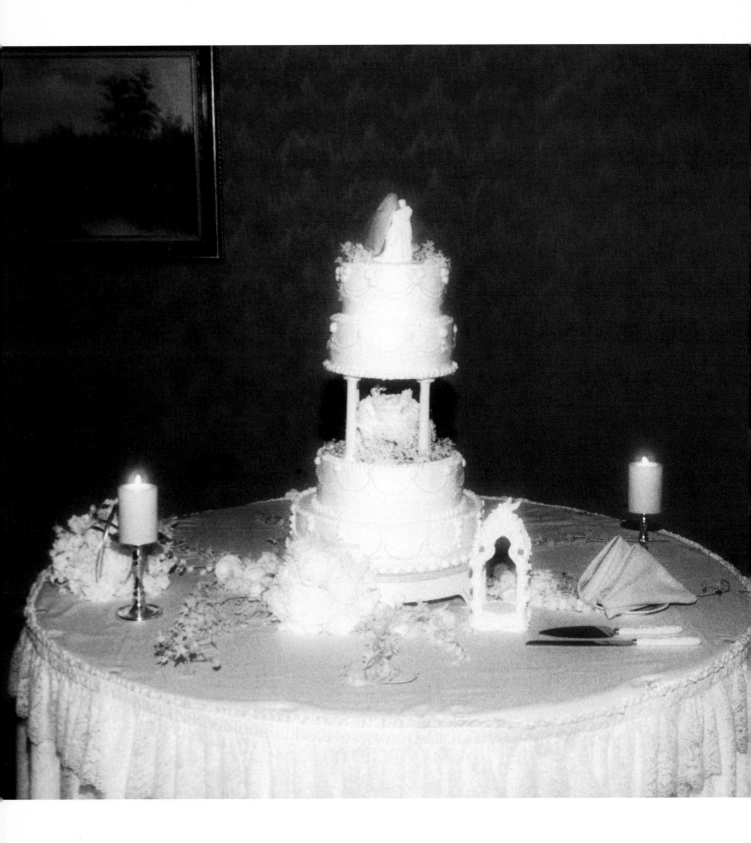

Technical Specifications

Travis created this image for the bride and groom of their wedding cake at the reception. He used a Minolta 35mm camera with a 28mm wide angle lens. The lens had a number 25 red filter attached to the front of it. Travis exposed the Kodak infrared film at ƒ8 at 1/60 with a flash on camera.

The Setting

This image is a typical wedding photograph taken in an unusual manner. The use of Kodak infrared film created an intriguing view of the couple's wedding cake on the cake table.

Composition

Travis took this from eye level, shooting slightly down on the cake table in order to see all of the elements in the image. The cake top and decoration are easily seen and the cake glowed nicely with the infrared film. Experience has shown Travis that this is a very pleasing angle on this type of image. The flowers, candles, cake knife and server added to the composition of this photograph.

Differences in Infrared

The two main differences in this image that set it apart from a regular black & white image is the increased grain and the bright glow of the white wedding cake. With infrared film, the flash illumination falls off very quickly and backgrounds are usually very dark. This adds to the stark contrast.

Photos without the Bride & Groom

Depending on the wedding, there are several photographs that we take that do not include the bride and groom, or other members of the wedding party and their family.

Some such images are "scene setters" (i.e. photographs of the outside of the house, church, reception site, etc.). We also try to focus in on the symbolic parts of the wedding (i.e. flowers, cake, candles, champaign glasses, etc). The key is to photograph the small details or, as we like to say, "If they spent money on it, get it on film." These images often end up being included in the finished wedding album and they are very profitable in our business.

INDEX

Other Books from
Amherst Media, Inc.

Basic 35mm Photo Guide

Craig Alesse

Great for beginning photographers! Designed to teach 35mm basics step-by-step — completely illustrated. Features the latest cameras. Includes: 35mm automatic, semi-automatic cameras, camera handling, *f*-stops, shutter speeds, and more! $12.95 list, 9x8, 112p, 178 photos, order no. 1051.

Wedding Photographer's Handbook

Robert and Sheila Hurth

A complete step-by-step guide to succeeding in the world of wedding photography. Packed with shooting tips, equipment lists, must-get photo lists, business strategies, and much more! $24.95 list, 8½x11, 176p, index, b&w and color photos, diagrams, order no. 1485.

Lighting for People Photography, 2nd edition

Stephen Crain

The complete guide to lighting. Includes: set-ups, equipment information, strobe and natural lighting, and much more! Features diagrams, illustrations, and exercises for practicing the techniques discussed in each chapter. $29.95 list, 8½x11, 112p, b&w and color photos, glossary, index, order no. 1296.

Big Bucks Selling Your Photography

Cliff Hollenbeck

A complete photo business package. Includes secrets for starting up, getting paid the right price, and creating successful portfolios! Features setting financial, marketing and creative goals. Organize your business planning, bookkeeping, and taxes. $15.95 list, 6x9, 336p, order no. 1177.

Outdoor and Location Portrait Photography

Jeff Smith

Learn how to work with natural light, select locations, and make clients look their best. Step-by-step discussions and helpful illustrations teach you the techniques you need to shoot outdoor portraits like a pro! $29.95 list, 8½x11, 128p, b&w and color photos, index, order no. 1632.

Make Money with Your Camera

David Arndt

Learn everything you need to know in order to make money in photography! David Arndt shows how to take highly marketable pictures, then promote, price and sell them. Includes all major fields of photography. $29.95 list, 8½x11, 120p, 100 b&w photos, index, order no. 1639.

Leica Camera Repair Handbook

Thomas Tomosy

A detailed technical manual for repairing Leica cameras. Each model is discussed individually with step-by-step instructions. Exhaustive photographic illustration ensures that every step of the process is easy to follow. $39.95 list, 8½x11, 128p, 130 b&w photos, appendix, order no. 1641.

Guide to International Photographic Competitions

Dr. Charles Benton

Remove the mystery from international competitions with all the information you need to select competitions, enter your work, and use your results for continued improvement and further success! $29.95 list, 8½x11, 120p, b&w photos, index, appendices, order no. 1642.

Freelance Photographer's Handbook

Cliff & Nancy Hollenbeck

Whether you want to be a freelance photographer or are looking for tips to improve your current freelance business, this volume is packed with ideas for creating and maintaining a successful freelance business. $29.95 list, 8½x11, 107p, 100 b&w and color photos, index, glossary, order no. 1633.

Infrared Landscape Photography

Todd Damiano

Landscapes shot with infrared can become breathtaking and ghostly images. The author analyzes over fifty of his most compelling photographs to teach you the techniques you need to capture landscapes with infrared. $29.95 list, 8½x11, 120p, b&w photos, index, order no. 1636.

Infrared Photography Handbook

Laurie White

Covers black and white infrared photography: focus, lenses, film loading, film speed rating, batch testing, paper stocks, and filters. Black & white photos illustrate how IR film reacts. $29.95 list, 8½x11, 104p, 50 b&w photos, charts & diagrams, order no. 1419.

The Art of Infrared Photography, *4th Edition*

Joe Paduano

A practical guide to the art of infrared photography. Tells what to expect and how to control results. Includes: anticipating effects, color infrared, digital infrared, using filters, focusing, developing, printing, handcoloring, toning, and more! $29.95 list, 8½x11, 112p, order no. 1052

Black & White Landscape Photography

John Collett and David Collett

Master the art of b&w landscape photography. Includes: selecting equipment (cameras, lenses, filters, etc.) for landscape photography, shooting in the field, using the Zone System, and printing your images for professional results. $29.95 list, 8½x11, 128p, order no. 1654.

How to Operate a Successful Photo Portrait Studio

John Giolas

Combines photographic techniques with practical business information to create a complete guide book for anyone interested in developing a portrait photography business (or improving an existing business). $29.95 list, 8½x11, 120p, 120 photos, index, order no. 1579.

Fashion Model Photography

Billy Pegram

For the photographer interested in shooting commercial model assignments, or working with models to create portfolios. Includes techniques for dramatic composition, posing, selection of clothing, and more! $29.95 list, 8½x11, 120p, 58 photos, index, order no. 1640.

Black & White Portrait Photography

Helen Boursier

Make money with b&w portrait photography. Learn from top b&w shooters! Studio and location techniques, with tips on preparing your subjects, selecting settings and wardrobe, lab techniques, and more! $29.95 list, 8½x11, 128p, 130+ photos, index, order no. 1626

Handcoloring Photographs Step-by-Step

Sandra Laird & Carey Chambers

Learn to handcolor photographs step-by-step with the new standard in handcoloring reference books. Covers a variety of coloring media and techniques with plenty of colorful photographic examples. $29.95 list, 8½x11, 112p, 100+ color and b&w photos, order no. 1543.

Family Portrait Photography

Helen T. Boursier

Learn from professionals how to operate a successful portrait studio. Includes: marketing family portraits, advertising, working with clients, posing, lighting, and selection of equipment. Includes images from a variety of top portrait shooters. $29.95 list, 8½x11, 120p, 123 photos, index, order no. 1629.

Black & White Photography for 35mm

Richard Mizdal

A guide to shooting and darkroom techniques! Perfect for beginning or intermediate photographers who wants to improve their skills. Features helpful illustrations and exercises to make every concept clear and easy to follow. $29.95 list, 8½x11, 128p, order no. 1670.

More Photo Books Are Available!

Write or fax for a *FREE* catalog:
AMHERST MEDIA, INC.
PO BOX 586
AMHERST, NY 14226 USA

Fax: 716-874-4508

Ordering & Sales Information:

INDIVIDUALS: If possible, purchase books from an Amherst Media retailer. Write to us for the dealer nearest you. To order direct, send a check or money order with a note listing the books you want and your shipping address. U.S. & overseas freight charges are $3.50 first book and $1.00 for each additional book. Visa and Master Card accepted. New York state residents add 8% sales tax.

DEALERS, DISTRIBUTORS & COLLEGES: Write, call or fax to place orders. For price information, contact Amherst Media or an Amherst Media sales representative. Net 30 days.

All prices, publication dates, and specifications are subject to change without notice.

Prices are in U.S. dollars. Payment in U.S. funds only.